THE HAUNTED HEART OF
DENVER

THE HAUNTED HEART OF DENVER

KEVIN PHARRIS

Published by Haunted America
A Division of The History Press
Charleston, SC 29403
www.historypress.net

Copyright © 2011 by Kevin Pharris
All rights reserved

First published 2011

Manufactured in the United States

ISBN 978.1.60949.293.9

Library of Congress Cataloging-in-Publication Data
Pharris, Kevin.
The haunted heart of Denver / Kevin Pharris.
p. cm.
Includes bibliographical references.
ISBN 978-1-60949-293-9
1. Ghosts--Colorado--Denver. I. Title.
BF1472.U6P465 2011
133.109788'83--dc23
2011030024

Notice: The information in this book is true and complete to the best of our knowledge. It is offered without guarantee on the part of the author or The History Press. The author and The History Press disclaim all liability in connection with the use of this book.

All rights reserved. No part of this book may be reproduced or transmitted in any form whatsoever without prior written permission from the publisher except in the case of brief quotations embodied in critical articles and reviews.

CONTENTS

Preface	7
Acknowledgements	11
Introduction	13
1. Corpses of Capitol Hill	15
2. A Life with Ghosts	51
3. Beastly Ghosts on Inca	63
4. Street Walking with the Dead in LoDo	69
Bibliography	109
About the Author	111

Preface

This little bit of my tale is entitled "The Accidental Ghost Hunter."

The only thing you really need to know about me is that I do not like to be scared. I don't watch scary movies, and I hope never to see a ghost. I didn't see my first horror movie until my English teacher in tenth grade showed the class two such films. To this day, I wonder what she was thinking. The movies traumatized me, and I had nightmares for weeks. Why would anyone do that to a kid?

Yet, for all that, here I am writing a haunted book, a book based on years of giving tours based on the scary stories of Denver. If you feel there is some kind of big disconnect between that fact and what I have just told you about myself, then you would be right on target. There is a big disconnect, and it is one of those weird twists in life that are utterly unpredictable.

You see, I started out as an English teacher, specifically English as a Second Language, known as ESL. I taught immigrants to Denver from all over the world, especially Russia, Sudan and Ethiopia. These folks were never going to be going home; they had immigrated for good. They all lived in the suburbs and thought downtown Denver, where I live, must surely be a dangerous place. Downtowns in movies are very dangerous places, so they assumed that what was depicted on film must be reality. This opinion of Denver offended me, so I started giving tours of Denver just to set folks straight, showing them the history of the city as well as its modern amenities. Thus, I started out as an accidental tour guide, based on history, a subject I really enjoy.

Preface

Then, my family and I took a little vacation to the New England states, and while we were there, we stayed at the Lizzie Borden Bed and Breakfast in Fall River, Massachusetts. I knew the rhyme concerning Miss Borden, but that was about it. While staying at the bed-and-breakfast, I learned a great deal about the story. I was particularly interested in the historical piece of the experience; my family was largely interested in the spooky piece.

Just in case you don't know it, here is the poem:

> *Lizzie Borden took an axe*
> *Gave her mother forty whacks*
> *When she saw what she had done*
> *Gave her father forty-one*

There are several versions with little changes here and there, yet this most common form of the poem actually differs hugely from the truth of the story. The instrument of murder was not an axe but a hatchet. Additionally, there were not forty and forty-one blows but, rather, eleven and nineteen. I guess accuracy was not too important when creating damning rhymes. Other facts, however, were incontrovertible. Mr. Andrew Borden, a relatively wealthy merchant in this thriving industrial town in Victorian New England, and his second wife, Mrs. Abby Borden, were killed on August 4, 1892. The scenes were horrific and caused quite a sensation in this quiet town. The sensation only grew when the second of Mr. Borden's two children, Lizzie, was accused of killing her father and stepmother. It was, in many ways, the crime of the century. Lizzie Borden was found not guilty, and the crime remains unsolved—and hotly debated—today.

I enjoyed my time at the Lizzie Borden Bed and Breakfast, learning about much of the historical and cultural minutiae that surrounded the case. My family reveled in the scary parts, which I tried to ignore. The tour guide that we had there that day was very interested in the world of the supernatural and how such things work. It was from this woman that I learned that there are three kinds of people when it comes to ghostly experiences. She called them ones, twos and threes. I know, not the most creative names, but she was pretty supernatural herself and didn't need creative names. Anyway, the ones are people who don't believe any of this stuff and are firm in their convictions that there are no such things as ghosts. The twos have had some interesting experiences, things that seem

to defy coincidence, but have yet to out and out see a ghost. The threes are those in full contact with the other side, like mediums or those cursed with such awareness (as you will see later in this book). Little did I know at that time that this information about ones, twos and threes would one day become very pertinent to my daily life.

After our visit to New England and the wonderful Lizzie Borden Bed and Breakfast (which I encourage you all to visit, because it is a thrilling place with numerous compelling stories and fascinating historical tidbits, like the part about the flea bites), we came home and I returned to the world of ESL. Eventually, my orientation tours of Denver for the students became standard offerings for many classes, not just my own students, and my colleagues would say things like, "Wow, you are really good at that! You should do that for a living." I would laugh and not think anything about it, until one day I had to think about my future. Yes, the private adult school where I had so happily taught was closing. I needed a new situation.

In a moment of sheer, profound insanity, I decided to go into business for myself with Denver History Tours and became a tour guide full time. I offered a number of walking and bus tours, set up a website, printed brochures and got myself a phone number so I could welcome all the people to Denver who were beyond eager to learn the city's history. I got some of those phone calls, sure, but the majority of the phone calls were for haunted tours.

Haunted tours! *Why would anyone want a haunted tour?* I wondered. It seemed to defy belief that folks would actually seek out something so unpleasant. Nevertheless, the folks were asking, so I asked my colleagues to provide. For two whole years, I managed to avoid giving every single one of those haunted tours, and there were a lot of them. Finally, it became evident that schedule considerations and demand would force me to learn the tour. I did so reluctantly and probably with ill grace, but I did so.

We had versions of the tour for LoDo and Capitol Hill. As I recounted the stories and led people on the hunt for haunts, I ended up learning many new things by being taken into the buildings, hearing more tales and learning more nuances and background. Thus, quite against my will, I ended up participating in the whole process of hunting for ghosts—I, the man who does not like to be scared and hopes never to see a ghost at all. So it was: I had become the accidental ghost hunter.

As you read about what I have gleaned in my years reluctantly giving these tours, just remember that each flirt with the other side has left me

Preface

quaking with the possibility that I might actually succeed in doing what so many people hope to do. Yet I have an innate propensity for historical accuracy and a devotion to the truth, so I relate these items as clearly and factually as possible in the hope that you will enjoy the fruits of my misfortune. In reading these pages, my fervent hope is that you will draw the ghosts to you and farther away from me. That would be a fine thing, I believe. So read of my experiences, walk the routes and take a ghost home with you! In that way, I will remain a "ghost hunter" rather than a "ghost finder!"

Acknowledgements

This book is written in memory of Ella of Eloise. I would like to thank my colleagues who have helped me find these stories and even experienced some of them for themselves. Thanks for sharing! Also, thank you to the people who have given me these stories as they welcomed me into their homes and businesses. Lastly, and most importantly of all, thanks to my parents, who have encouraged me to write and have never given me anything but support and love. You have helped me explore the world of wonderment. Thank you! Love also to Sibadili Nia Kwa.

Introduction

In certain instances in this book, the names of people who have experienced these events have been changed so as to protect their anonymity from the possibility of obtrusive ghost hunters. Historic names, however, have not been changed, nor have any addresses listed.

So, we start with a brief history of Denver.

As folks zoomed westward across the United States looking for gold in what would become California, they naturally searched for some gold along their way. In 1858, cities began to spring up in the area of what is now Denver as folks tried to secure the rights to the riches they felt sure to find. With St. Charles on the northeast side of Cherry Creek and its rival city Auraria on the southwest, events were set in motion to create the Mile High City. William Larimer came to the region and made St. Charles his own, naming a main street after himself and changing the name of the city to honor the man who was, at that time, territorial governor of Kansas, James Denver. No American had the legal right to make a city in the region, for it belonged to the locals by treaty, but the American government was far away and preoccupied with the coming storm of war. In the West, racism and the lust for gold would blind the Americans who arrived, gradually and sometimes violently disenfranchising the Indians from their promised and rightful lands.

Growth was slow at first for Denver City, as it was then known. Even after absorbing its rival across the creek, the city's future was uncertain. When Colorado Territory was formed in 1861, Denver City felt it should hold the

Introduction

title of territorial capital. The city of Golden wooed the territorial legislature to the base of the foothills for a period in the 1860s, but before the decade ended, Denver had regained the honor of being territorial capital. This was achieved partly through using Golden's methods of inducement (free liquor and the like) and partly through the gift of a man named Henry Cordes Brown, who offered some of his land for a capitol building.

In the late 1860s, the Union Pacific Railroad was planning a route through Cheyenne that would surely spell growth for that city at the expense of Denver. Fortunately, visionaries worked to create a train line to Cheyenne so that the first trains to reach that city could also make the brief detour into Denver. Soon there were so many train lines bisecting the western United States that it did not matter, and Denver's preeminence in the area was secured.

The decade of the 1870s saw enormous growth for the city, with the train allowing for the arrival of people as well as goods. Immigrants from around the world poured into Denver, contributing to the richness of its tapestry. The rowdy city was gradually reborn. Wooden buildings were replaced by ones that were meant to last the ages and reforms were carried out by the civilizing forces coming to tame a lawless land. The city's growth continued, especially toward the southeast and the location of the state's future capitol. The piece of land owned by Mr. Brown, once known simply as Brown's Bluff, was now becoming the fashionable part of town, styled as Capitol Hill and, eventually, Millionaires' Row.

Through economic upturns and downturns, mining booms and busts, agricultural expansion and water woes, Denver made its way with the bravado typical of the Wild West. From the original urban core, known as Lower Downtown (or LoDo), to the neighborhoods that housed poor or rich according to the fashion of the day, Denver has had plenty of adventure in its brief life. Still, don't let the modern city fool you. Though Colorado may seem quite refined, Denver is still a cow town in its heart, and we have not yet thrown off our rough-and-tumble roots. To prove it, I offer you this: find the finest hotels in the greatest cities of the world, and I guarantee that those hotels will not play host to a gigantic urinating and defecating bovine in their atriums once a year. We proudly display the prizewinning steer from the National Western Stock Show in the lobby of the Brown Palace Hotel every winter, and it is a huge event. Denver will always be the bridge between plains and mountains, the heart beating wildly for the future even as it murmurs lovingly of the past, that place as beautiful as the dazzling sky above it all. It's no wonder we have so many ghosts; who would ever want to leave?

CHAPTER 1

CORPSES OF CAPITOL HILL

This chapter will guide you on a tour filled with stories heading through the Capitol Hill neighborhood, sharing the chilling tales my colleagues and I have gleaned over years of discussing the ghosts in that most densely populated part of the state. If you follow directions well, you will even be able to walk the route and see all the buildings in question. As far as seeing an actual ghost, we make no promises, but hey, you might get lucky! So put a bookmark here at this spot, close your book and get yourself to the west side of Colorado's marvelous gold-domed capitol, there at the southeast corner of Colfax and Lincoln Streets. Resume reading once you are ready to go.

(Mood music goes here, so hum to yourself as you make your way to the capitol.)

Are you there on the west side of the state capitol? Great! Let's get started then.

On the west side of the capitol in downtown Denver is a famous step with words carved into it proudly referencing the moniker attached to the city: One Mile Above Sea Level.

Do you see it? Hunt it up, find it, sit down so that your posterior is exactly a mile high and continue reading!

If you look off to the northwest (that's toward all those skyscrapers over there), you will see a building peeking over the top with the word SHERATON written in big red letters. That's what is there at the time of this writing, at least. At the corner of the 16th Street Mall and Court Place, it has had a few names over time and might change again in the future. Either way, that's

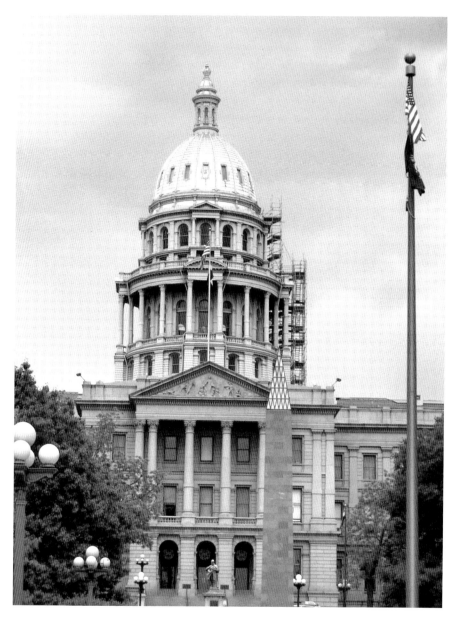

The capitol of Colorado stands as the visual transition between the skyscrapers of downtown and the residential neighborhood of Capitol Hill. A beautiful building inside and out, it anchors the eastern end of Civic Center Park.

Corpses of Capitol Hill

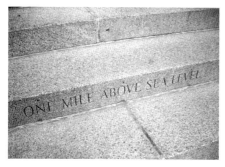

The famous ONE MILE ABOVE SEA LEVEL step beckons tourists to the western side of the capitol. When standing on this step, visitors are one mile high and have an excellent view of the city and Rocky Mountains.

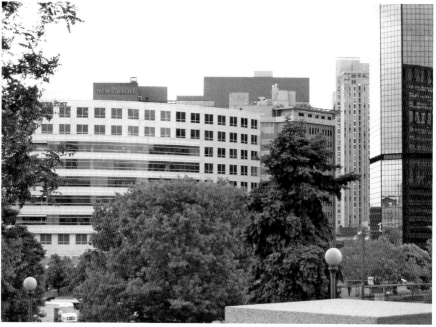

From the vantage point of the capitol steps, one may look northwest and see the towering buildings of downtown. Among them, red letters proclaim the location of the Sheraton Hotel, at the corner of the 16th Street Mall and Court Place. One of the building's predecessors was touched by the infernal.

the building you may admire from your seated position there on the steps because that building is the scene of our first story, one that sets Denver apart from every other city around, at least as far as we know. Long ago, before it was a hotel, before it was a hyperbolic paraboloid, it was the Arapahoe County Courthouse. It was also the location of the Gates of Hell.

Yes, you read that right. It was the location of the Gates of Hell. In the summer of 1900, the elevator shafts in the basement would open and the

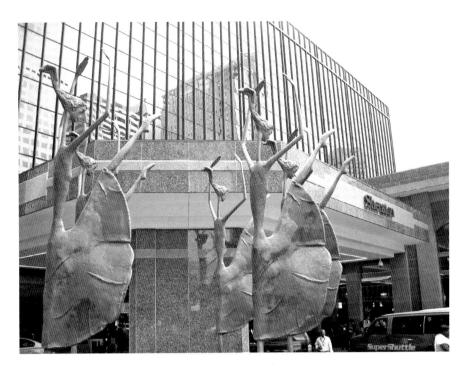

For those wishing to enjoy the amenities of the Sheraton Hotel, these festive ballerinas mark the entrance to the building and are frequently admired by folks passing along Denver's most popular tourist attraction, the 16th Street Mall.

dead would walk among those on duty guarding the place overnight, to the accompaniment of unnatural lights and the smell of brimstone. The Arapahoe County Courthouse had seen many people consigned to their various fates for whatever ill deeds they had accomplished. Apparently, some of them ended up on the infernal side of things after their deaths and came back to the site of their sentencing. The gates had never opened before and have not opened since, but Denver gets to claim access to the underworld, a claim I have yet to hear associated with any other city on earth. No wonder there are so many ghosts here. Way to go Denver!

So if you would like to get to hell and you don't have a lion, leopard and she-wolf to get you there, just go to the Sheraton Hotel in downtown Denver. Check in to your room and do something naughty. I will leave the decision on what qualifies as "naughty" up to you. You might get the Gates of Hell to reopen once more. Just make sure to take some marshmallows.

Before we leave the capitol behind entirely, it should be noted that numerous folks have declared the capitol itself to be haunted by a floating

head, one removed in the 1860s from one of the famous Espinoza brothers of the San Luis Valley. The other Espinoza brother was also decapitated, but the ghost of his head must haunt elsewhere. There's certainly plenty of gruesome detail surrounding how these fellows ended up having their heads separate from their bodies, and there are authors who have spoken with people who affirm one of the ghost's occupation (his head at least) of the capitol. For my part, I once asked a colleague about the ghost in the capitol. She had worked there for many years and told me, flatly, that there was no ghost in the capitol, no way, nada, zip, don't even think about it, zilch, ubsoyo, zero, nul. Rather than incur her wrath (for she is a fine as well as formidable woman), I will go with there being no ghosts in the capitol. Between you and me, however, please let me know if you are visiting the beautiful Colorado state capitol and happen to run into Mr. Espinoza's head floating about some corridor. As you will see from the ensuing paragraphs, I am always gathering new information for my repertoire.

Now that we have finished with our see-from-the-step stories, let's get off that One Mile Above Sea Level seat of yours and head deeper into Capitol Hill. In order to continue your tour, head to the south side of the capitol. You'll be at the corner of Sherman and 14th Avenue. Keep walking east (which is away from the mountains) and you will soon reach Grant Street. Perhaps you are noticing a theme with the streets: Lincoln, Sherman, Grant. You amazing historian, that's right! These are named for some of the prominent figures from the Civil War. Once you reach the corner of 14th Avenue and Grant, head south on Grant and continue to read. I will give you a little primer on the history of the neighborhood you are entering. You should keep an eye on the sidewalk and the traffic and avoid tripping, running into another pedestrian or getting squished by a vehicle. When you have crossed 13th Avenue, you will soon come to a beautiful mansion on your left at 1244 Grant Street, which will be our first stop.

As you are heading south on Grant Street, you are heading into what most people would consider the heart of Capitol Hill, the most famous neighborhood in the entire city, I would say. Before it was known as Capitol Hill, its nickname was "Millionaires' Row." Before that, it was simply and somewhat derisively known as "Brown's Bluff" for the man who owned it. The Homestead Act was an effort on the part of the federal government to get folks to move into the empty-of-Americans West, thus displacing the people who were already there (Native and Mexican alike) and securing the land for the United States. Through the Homestead Act, people would be given up to 160 acres for free with the understanding that they had to remain

on the land for at least five years and make improvements to it. Should they satisfy these requirements, the land would be theirs. Many homesteaders took advantage of this opportunity, among them a fellow named Henry Cordes Brown. He ended up with an area southeast of the infant settlement then known as Denver City. The area was sere, devoid of trees and really quite a long way from the hustle and bustle near the confluence of the South Platte River and Cherry Creek. Sure, the area had some height and offered a fine view of the mountains to the west, but anyone who thought this land would be anything was either chewing on some loco weed with the cows or simply deluded.

Mr. Brown proved there was another option. The subject of what city would be the territorial capital for Colorado was one that much preoccupied the populace, with Golden and Denver City among the forerunners of the cities vying for the honor. Denver City wanted it, but how could Denver City get it? Brown had the perfect answer, one that would satisfy the forward-looking people of Denver and make Brown's land suddenly a lot more valuable. He "generously" donated ten acres of his land to serve as the grounds for a future capitol. Denver City graciously accepted and eventually used the space for the construction of the capitol. Your derriere was recently firmly planted on a staircase set on those ten acres, just so you know. Denver City got the title of capital (which it would retain once Colorado became a state), and Brown's land became really valuable, which is what Brown had intended all along, this leading to my putting the word "generous" in quotes.

The city, which had been growing toward the northeast along the named streets of downtown, took a ninety-degree turn to the right and began growing toward the southeast. This would have a number of effects, some intended and some not, as we shall soon see. For now, simply understand that Brown's land was valuable and he became a rich man. Rarely did any homesteader make such grand improvements to his/her land.

By the late 1800s, the streets of the neighborhood played host to all the big names and all of their big houses. Unfortunately, things changed. With economic ups and downs, as well as the fickleness of architectural fashion, the great houses of Millionaires' Row began to come down during the urban renewal efforts of the mid-1900s. The corner of 12th Avenue and Grant Street used to be known as "Millionaires' Corner" for the truly spectacular homes that graced each point on the compass. You'll see that there's not much there now by way of megalithic mansions.

So, by this time you should have made your way to 1244 Grant Street, the Cresswell House. Built for a gentleman who made his money providing

Corpses of Capitol Hill

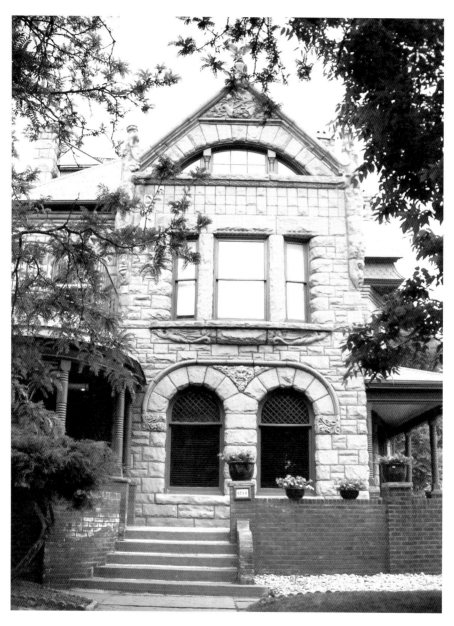

The Cresswell House, located in Denver's scenic Capitol Hill neighborhood, is home to a virtual pantheon of decorative figures as well as ghosts—unless you're a doubting electrician, in which case the place just needs some repairs.

the infrastructure to do the steam heating of downtown buildings, it is an artistic and architectural marvel, and haunted too. Spooky! Stand on the sidewalk and gaze up at the house. Just to be polite, you should resist the temptation to stand on the lawn or go up to the porch, since that could be construed as trespassing.

Now, in the olden days, people used to show their worldliness and education by referencing the classics: the cultures of Greece, the architecture of Rome, the ancient folks who had inspired awe and emulation for millennia. Over the years, the building has become a virtual menagerie of the world's imagery, with time and different residents adding things to the exterior or the walls. So, at the top of the building, we see an eagle, wings spread and worthy of adulation, indicating someone's patriotism first and foremost. Immediately below the eagle, you see a cornucopia and other classical Greco-Roman imagery. At the lower corners of the roofline triangle, on either side of the eagle, are two odd-looking dogs. At the time Mr. Cresswell had the house built, the exotic Orient was hot, and that fascination continued into the twentieth century. Unfortunately for whoever put those dogs up there, that person did not quite get the details right, though I imagine the Asian-focused individual probably didn't know or care. Those animals are called Fu dogs. In the spirit of symmetry, there are supposed to be a male Fu dog and a female Fu dog. One of the female's paws is supposed to be held somewhat upright, resting on a sphere, that sphere representing an infant Fu dog. Thus, the Fu trinity. If you look closely, you'll see that Mr. Cresswell's house is graced by two *male* Fu dogs. Again, someone probably wasn't paying too much attention, but I was told by someone who knows about the way things work with such imagery that having two male Fu dogs will mess up the building's lay lines. I know anyone messing with my lay line would be a bad thing, so it's easy to see how screwed up lay lines could lead to a place being haunted. Think about it.

Enough about screwing with someone's lay! If you look below the second-floor windows, you will see winged creatures of the British Isles, most likely drakes, wyverns or griffins.

Finally, between the first-floor windows, the face that causes much of the consternation for the building. If you are working with the imagery of the Greco-Roman world, it could be Bacchus or Pan, perhaps a satyr even. If referencing the mythology of the British Isles, the Green Man or the Horned God, perchance. During my tours, I have had a number of people look at the face and say, "Clearly, that's the face of the devil. Satan himself looks out from the front of the building." I don't actually know, and Mr. Cresswell

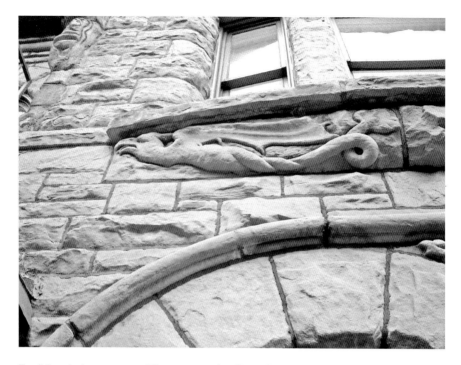

Possibly a drake, wyvern, griffin or some other figure from the mythos of the British Isles, this decorative element and its twin may be found under the second-floor windows of the Cresswell House.

didn't leave behind architectural renderings with notes in the margins that I have been able to peruse: "Put face of Satan on front of house, which is sure to be a talking point for guests. Perhaps it will keep mother-in-law from visiting, though there's always the chance she may come more frequently, recognizing her boss." Nope, no such luck in finding such notes, so we must do our best to interpret.

While many folks on my tours have thought that it is this face that draws in the negative energy that bedevils the place, my personal opinion is that no one in the Victorian era or most any time period would have put something hellish on the front of his or her home. Still, stranger things have happened, and the world of the occult was much more a part of people's days than we might think. More on that later, however.

When I first began giving this tour, I had read of various poltergeistesque activities within the mansion and would relate these on my tour. One day, as I was standing outside with my tour group, a lady opened the front door and called out, "Hey, what are you doing?"

"I'm giving a haunted tour."

"Well, come on in. I'll show you around and tell you about what happens here!"

Blink blink blink.

"Okay!"

So we shuffled in and admired the interior of the Cresswell House, which these days serves as rental office space. Though some folks refer to this place as a mansion today, in the Victorian era it would have been seen as an upper-middle-class home. Mansions were built on corners, as we shall see further on the tour. Some of the beautiful details in the Cresswell are still present, especially around the fireplace on the ground floor. Other areas have been altered to their modern form. We mingled in the foyer, and the lady told us the building's tale.

> *This building is one of the properties managed by the company that I work for, and we have the hardest time keeping tenants in here. People feel as if they are constantly being watched, and not a nice "Hi, I'm a friendly ghost and welcome to my home" being watched. No, the sensation is one of trepidation, the feeling that someone unpleasant is sneaking up right behind the person, intent on malevolence: "If I could only manifest, I would strangle you to death right now."*

Most of us know the sensation of having someone sneak up behind us, so you should be well able to imagine the feeling. That doesn't make for a calm work environment, now does it?

That's it. Doesn't sound too hideous, but it is. With that sort of sensation, it's almost impossible to be relaxed at work. For one day, it's not such a big deal. Day after day, week after week, and it's a problem. The lady told us that people would go home from work exhausted, not from the work of the day but from constantly being on edge. So the building would go through company after company as people succumbed to the overbearing threat in the air.

After her kindly offered turn about the place, we left and continued our tour. I was happy because I had another story to add to my tour. It was a good day. Oddly enough, the stories I would garner from the Cresswell home were not yet done.

I began telling this story preferentially, the truth of the threatening presence within the home. On occasion, folks would offer their own thoughts on the face on the front of the building, and everyone agreed that the grinning visage was peculiar, if nothing else.

Corpses of Capitol Hill

Now when you're giving a tour, it's always easy to tell who the ones are, the people who simply don't believe in ghosts. (For a fuller explanation of these labels, please see the preface at the beginning of the book.) Ones have usually been dragged along by their spouses, and they spend the bulk of the tour with their heads tilted slightly back and, the indicator of indicators, with their arms crossed. On one of my tours, when I had just finished recounting the problems with the Cresswell House, one of my ones on the tour piped up, saying, "That's @%*#."

My ears turned red because, as you may well imagine, I am a gentleman and never utter such things.

> *There's no ghost in there. I know the problem, and it's nothing haunted at all. I am an electrician, and I've dealt with this for years. People whose electric boxes are set too high report the same kind of thing. Having your electric box set too high creates this inaudible vibration in the air. You may not be able to hear it, but you can sure feel it, in your nerves and in your bones. That's all they need to do here, just have an electrician come in and get their place fixed.*

Not being an electrician, I had no response to that, but it sounded just as likely as anything else, so I began to add that to my information about the Cresswell House. More time passed, and I didn't have any more electricians, but the story was not yet done.

One day, after relating the original information from the property manager and the comments from the electrician, I had a three on the tour, and she protested the man's assessment with great energy and animation.

> *Oh no, no, he's quite wrong. He fails to understand, he fails to understand! It is quite difficult for a spirit to manifest on our side of the veil, and our limited awareness makes their efforts even more arduous to sustain. What this man did not understand is that electrical emanations are a primary form of sustenance for the non-corporeal, allowing them greater ease in manifestation as well as maintenance. This place might have its electrical box set too high, but that would only serve as a beacon, a bright lighthouse calling all the spirits in the neighborhood to a smorgasbord. This place would be ghost central.*

What could we say to that? We admired her, and she nodded sagely, and we continued on our tour.

So, the Cresswell House, whether you're a one, two or three, definitely has something going on, and all things architectural might have something to do with it. You just never know.

Now that we have finished at the Cresswell House, we continue our tour, walking south on Grant Street. You'll cross 12th Avenue and soon, on the eastern side of the street once more (like the Cresswell House), you will come to 1128 Grant Street, the Whitehead-Peabody House.

William Whitehead was a doctor who came west after the Civil War. James Peabody was involved in Colorado politics and even served as governor. Both gentlemen lived in the home at one time, lending their names to their former residence. The Whitehead-Peabody House has quite a few spooky elements, and a number of authors have written about the ghosts within, including those that haunted the premises when it was a creatively named bar, Spirits on Grant Street. Various ghost-hunting folks in Denver have done séances and the like there. One ghost hunter told me that it was the

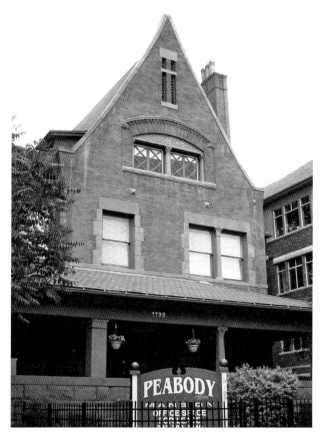

The Whitehead-Peabody House has been plagued by ghosts throughout its many years, and many who have entered the building seeking them have felt their wrath. Other ghosts within are younger, relatively speaking, and prone to the occasional temper tantrum.

most haunted structure he had ever entered, and he had been all over the country in pursuit of that touch from the other side. My own connection, my own personal story to the building, came at Halloween, when I was giving a walking tour of the neighborhood. Though the place started out as a house, today it is rental office space. On this particular evening, the staff members of the various offices were having their annual Halloween party. As I related the basics about the house, we saw people wearing all the standard costumes of the holiday, from bimbos to zombies, and carrying all the food for the party. A lady, dressed like the television character Elvira, came out and asked, "Hey, what are you doing?"

"I'm giving a haunted tour."

"Well, come on in. I'll show you around. We have the basement decorated like a graveyard, including the guy who hanged himself."

Blink blink blink.

"Okay!"

> *Before, we go in, however, I have to tell you what happened to me here. Now, I work up there, by those second-floor windows, with another lady next to me. Our boss works farther back in the building. My colleague and I have frequently seen a ghost toddler walking around, this little two-year-old boy. He's so young that it's always more of a sad thing to see him than a scary thing. Anyway, we've mentioned, once or twice, our seeing this ghost kid, and our boss doesn't believe it at all.* [Clearly he is a one.] *He thinks we're imagining things or making a joke. So, one day my colleague and I are sitting there working and our boss comes storming out of his office, with his face red, absolutely livid, and he starts to yell at us. "Who brought a baby to work? This is not a day care or nursery! I can't get any work done with that baby crying. Where is that baby?"*

The woman à la Elvira related how, at first, she and her colleague had no idea what he was talking about, since there was no baby. Then, suddenly, it hit her.

"You heard the ghost baby! Come on! Come on! You can't deny it! There's no baby here. You've been hearing a ghost!"

She went on to say that the man's face went from red to white in a second or two, his eyes getting wider, before he began to stammer out, "Oh, ha ha ha, I was just joking…I was just…yeah, um, I didn't hear anything…just…just a joke, ha ha ha." Then he stumbled back into his office, and they heard nothing more from him on the subject.

She motioned us into the building. Two of my guests on the tour that evening declined to enter. We took the tour of the beautiful building, including a jaunt down into the unfinished basement on the perilous stairs, the wooden stairs that echoed loudly, like the promise of approaching doom.

Now, you might not know much about me (unless you have read that preface thingy), but here is where I have to share an important little detail about me: I have a very active imagination. Yes, it is true. No dullard, I! So I need you to take this next bit with the proverbial grain of salt, knowing that I have an active imagination and that, at this point in our evening, we had just been talking about ghosts, ghosts and more ghosts, especially those related to the mansion we were about to enter.

I have just told you how the stairs echoed very loudly, my footsteps seeming to create a sound that was much louder than I had anticipated. I wondered at the ponderous tone the stairs created as I descended, and it was decidedly creepy. As my first foot touched down onto the dirt floor of the basement, two things happened in that exact moment.

First, the sensation beneath my foot was not initially that of stepping onto hard packed dirt. Rather, it felt as if I had stepped onto something brittle and weak that shattered and collapsed beneath my weight.

Second, within my head, I heard my own voice stating something, though not as if I had generated that thought myself. No, it was as if someone was speaking within my mind, using my own voice to tell me something. The words that I heard in my head mingled perfectly with the sensation that I felt beneath my foot: "You are not stepping on dirt. You are stepping on a field of bones."

The voice within me, though my own voice, rocked me to my core, even though the sensation beneath my foot vanished in a mere instant. I was pretty shaken up but soldiered on as bravely as I could, at least for the moment.

The place was, indeed, decked out like a cemetery and included a mannequin hanging from a water pipe, twisting slowly back and forth—the mannequin, not the water pipe—and the effect was quite grisly. At this point, I had had enough, thank you very much, and excused myself to go outside. A few minutes later, our unexpected but welcome jaunt into the Whitehead-Peabody House came to an end with the remaining folks returning to the sidewalk so we could compare notes.

A number of folks on the tour had felt things in the basement, including pockets of chilled air and vortexes alternately described as having "extra gravity" or "denser air." Everyone agreed that the place had a very high creep factor, so they were ready to depart as soon as possible. Instead, I

made them remain right there in front of the building while I told my next story. Not very accommodating, perhaps, but it kept the mood right for our next tale.

So, from your vantage point in front of the Whitehead-Peabody House, rotate in place and look at the gigantic red mansion to your southwest, at the northwest corner of Grant Street and 11th Avenue. That is the most carefully pronounced name in Denver history. It should be said very slowly, so no one thinks you are saying anything else. The first syllable sounds like the word SHE with a nice long EEEE sound. Yep, that's the home of Dennis Sheedy. Seriously, don't say the name too fast or the third and fourth graders in your life will enter a state of high pandemonium.

When we began giving this tour, we didn't have any haunted stories about the Sheedy Mansion, but then a colleague of mine had an amazingly brilliant idea: "Let's write letters to the old mansions and businesses of Denver and ask them if they have any haunted stories!" Yes, let's!

Though we had had no stories concerning the Sheedy Mansion before, we got a great one back after our letter-writing campaign. Look at the northern side of the building, where you see that little covered entryway. Just inside that door is the foyer of this former house that is now an office building. The letter we received details the sad story of what happens within that foyer.

People will, on occasion, see a woman in the foyer dressed in the garb of a Victorian lady. Those who work in the building know that she is a ghost and watch her without responding, but those who are unaware of her supernatural status are moved to render aid. The woman's face is one of intense alarm, her mouth moving rapidly. She gesticulates toward a door, clearly pleading for assistance. Those who see her easily understand that something ghastly has happened. What is it? A fire? Has someone fallen? Most folks, wishing to help and moved by the look of panic on the woman's face, rush to the door and open it, only to find no one there. When they turn back to the woman to ask her intent, they find that she has vanished.

What happened that is so troubling for this woman? We may never know because of one key element missing from this somber tale. Though her mouth is moving a mile a minute, there is never any sound. I have asked folks why. Some who study the world of the supernatural have told me that this woman is likely under a thrall, silenced for all eternity by the will of another. Others have stated that she is not a ghost at all but something simpler still. Apparently there are two kinds of wraiths left behind after death. Some are sapient, able to converse with the living, possessing true memory and awareness, if limited by the misty barrier between our world

The Haunted Heart of Denver

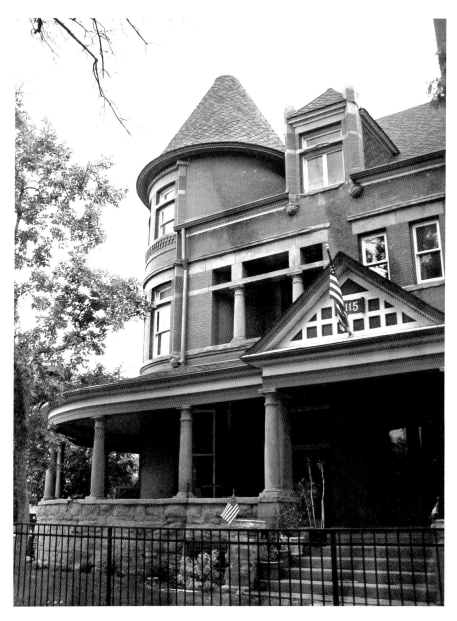

The Sheedy Mansion, located at the corner of 11th Avenue and Grant Street, is haunted by an emotional echo, a sad presence consigned to spending eternity in silence.

and theirs. Others, like the woman in the foyer of the Sheedy Mansion, are not true ghosts at all. Rather, they are what would be called emotional echoes. When a person experiences something of truly staggering emotional power, that experience may actually leave an imprint on the fabric of space, like a footprint in the sand. Occasionally, that imprint surfaces once more, a replaying of something long ago felt. Given that the woman in the foyer always does the same thing, many of Denver's ghost hunters conclude that she is likely an emotional echo rather than a truly sapient ghost. Either way, it strikes me as a horrible thing to repeat the same six or seven seconds for all eternity. What happened to this woman to ensnare her in this loop? Was it her death, or perhaps that of a loved one, or some other news too shocking to tell? Perhaps she has silenced herself rather than reveal the truth of what she once knew. Our only hope is that one day, by some weird chance, someone who has the ability to read lips will see her. Then, perhaps, we will learn the message that has been so long offered in silence.

Now we must leave Grant Street. Continue south until you reach 11th Avenue and turn left, heading eastward. You'll cross Logan and soon come to the corner of 11th Avenue and Pennsylvania Street. There, at the southwest corner, you will see the marvelous Croke-Patterson-Campbell Mansion. I am sure you will agree that this well qualifies as a mansion!

The Croke-Patterson-Campbell Mansion was built for carpet dealer Thomas Croke in 1891. This beautiful French chateauesque structure did not remain his home for long and was soon purchased by *Rocky Mountain News* owner Thomas Patterson. A staunch Democrat with a fascinating

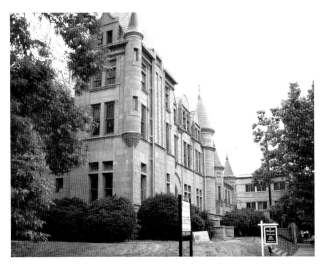

The Croke-Patterson-Campbell Mansion is both a beautiful example of Chateauesque architecture and would make a fine bed-and-breakfast. The person undertaking this task would simply have to set out a plate each morning for the building's numerous restless residents.

story in his own right, Patterson left the house to his Republican-leaning daughter, Margaret Campbell, and her husband, Richard. The Campbells left Capitol Hill for greener pastures in the 1920s, thus beginning the decline of this wonderful mansion. After the departure of the Campbells for a new home in the posh Morgan Addition of Denver (they moved into the Waring House, which we will discuss shortly), the place became apartments, office space and a single-family home over the years. During its days as apartments, the building was famous for horrible sounds coming from the third-floor corner room on the northeast side. It is also renowned for being notoriously anti-canine, to the point of doggy death. This is, perhaps, the most famous story of the Croke-Patterson-Campbell Mansion, the fact that it has driven dogs to leap to their deaths from the upper-floor windows. Let me tell you of my own encounters with the Croke-Patterson-Campbell Mansion, however.

One day, I was giving a walking tour through the neighborhood, and it just so happened that I had one person with me. Yep, a tour for one. She had a digital camera and wore a fleece jacket that proudly proclaimed "Ghost Hunters of Ohio" or someplace in that part of the world. As we made our way along, she was taking pictures of every inch of our route, no doubt looking for orbs or some other indication of the supernatural.

Are any of you tour guides? If so, you know that when you are doing a tour for one person, you really have to be dynamic, dramatic and large to carry the energy along. So, in a deep and booming voice, I proclaimed that we had reached one of the most haunted buildings in Capitol Hill. With a delighted little trill, she pointed her camera at the Croke-Patterson-Campbell Mansion to begin the photographic barrage.

Tzzzzzzt. Tzzzzzzt. Tzzzzzzt.

Her digital camera refused to take a picture of the building. She kept pressing the button, and it kept right on making a sound of protestation and taking no picture at all.

"Hmmm, that's funny. I wonder what's wrong with my camera," she murmured, which was a good question because she had probably taken several thousand pictures by that point on the tour. In a bit of experimentation, she turned and pointed her camera at the red brick apartments on the north side of the street.

Click!

"How strange," she ejaculated and then turned back toward our camera-shy haunted mansion.

Tzzzzzzt. Tzzzzzzt.

At this point, the woman's eyes expanded by several inches as her mouth made a wide O shape. "The spirits in the mansion don't want me taking a picture of them and their home! Oh my, they've reached out and denied my camera. My camera has been touched by their power! Oh my!"

The woman was beatified. She didn't wet her pants, but almost. I could have said nothing for the rest of the trip, and she would not have known any different, because all she did for the rest of the tour was talk about what had happened at the Croke-Patterson-Campbell Mansion, how the ghosts had made their presence known in a very powerful way. For myself, having heard the camera click quite a few times, I do have to say that it was extremely unnerving to listen to her camera fizzle out each time she tried. I guess even ghosts don't like the paparazzi.

My next encounter with the mansion would be more intimate still. It was a rare kind of autumn in Denver, so I remember it well. Usually the weather remains mostly mild until Halloween and then we have our normal Arctic annihilation, just in time to ruin the festivities for the wee kidlings. This has led to parka-based costumes being de rigueur for Denverites. This Halloween, however, we were enjoying more than just a break from the normal mode. We were having a mighty heat wave. I was giving all my haunted tours in shorts and short-sleeved shirts.

By this time, the Croke-Patterson-Campbell Mansion stood empty, its last resident having moved out six months earlier. I told my stories of the mansion, the backdrop of the silent house behind me augmented by a "For Sale" sign, and then the door opened. A lady called out to us.

"Hey, what are you doing?"

"I'm giving a haunted tour."

"I just got done doing a showing, would you like to come in?"

Blink blink blink.

"Okay!"

As we drew up to the door, the lady drew our attention to a piece of paper that had been affixed to the door on the right. It said "Building Is Not Climate Controlled." She explained, "Since no one is living here, we are not running the air conditioning. No need to use all that energy when no one's in the house to justify it, but it does mean that we're going to have a hot time of it, I am afraid, because it is such a hot day."

She was correct on that score. It had been quite hot outside, and the inside was baked to the stifling point. We had a tour of the place, an odd arrangement of rooms and corridors surely reflecting the frequency with

which the place had been shuffled back and forth between being apartments, office space and a single-family home.

Then we entered the third-floor corner room, looking out toward the northeast, and all of us felt it: the temperature had experienced a precipitous drop, meaning that what had been fine weather for shorts and T-shirts was now shiver-worthy and very engrossing, for the presence of ghosts is often associated with lower temperatures. It was not I alone who felt it. We all did, reminding us that we had entered the room within the building famous for nightmarish, otherworldly sounds. Brrrrr! Or should I say boo?

The best story of all for the Croke-Patterson-Campbell Mansion, however, was experienced by a colleague of mine. He was giving a tour through Capitol Hill when the most recent resident still lived there. This gentleman opened the door, having noticed a group of folks stopped at the base of his stairs.

"Hey, what are you doing?"

"I'm giving a haunted tour."

"Come on in, I'll show you around!"

Blink blink blink.

"Okay!"

This kind fellow was true to his word, showing them around his home. Finally, one of the ladies on the tour asked him if he had ever experienced anything. He took them to a bathroom toward the rear of the house, a large and somewhat oddly shaped room. There, he stood by the sink and began his tale.

"I am a man of science, and I don't believe in such things. However, let me tell you what happened to me. I was standing here, brushing my teeth, when I heard something rattling the shower curtain," he said, pointing at the bathtub and the shower curtain hanging from its shower rod, some six feet away from the sink, behind him as he faced the mirror. "I thought it was one of the cats, so I walked over there and looked in the tub. Kitty? Kitty? Nope, no cat there. I didn't think anything about it and went back to the sink to finish brushing. Behind me, quite suddenly, the shower rod and curtain leapt from their space on the wall and flew across the room toward me," he continued, pointing to an area near his feet, far from where the common preference of gravity would have normally led the shower rod and curtain to have fallen. He concluded his story by telling the group that he went racing out of the bathroom, scared by the violent expression of someone he could not see.

One of the ladies on the tour, stunned by the story, cried out, "That happened and you're still living here?!"

To which the group's host replied, "Well, it was only once."

Any good scientist will tell you that an experiment may not be proven a success unless it may be repeated, so this was evidently not scientifically substantiated, but it left a mark on those who heard the tale and remains firsthand evidence of the goings-on in the Croke-Patterson-Campbell Mansion. At the time of this writing, the house sits forlornly for sale and would make a superb haunted bed-and-breakfast. If there are any millionaires reading this book with lots of money and nothing to do with it, I want you to put this book down *now* and do two things: first, immediately give me a call and let's be good friends (I've always wanted a millionaire for a friend, and I have countless ideas to make you millions more!); and second, buy the mansion and make it what it was destined to be: an opulent and wonderful haunted bed-and-breakfast, offering respite for folks on both sides of the divide, so to speak. I suspect that a certain lady ghost hunter from the Midwest will be the first through your door.

The former owner did mention that his cats died in the house under mysterious circumstances (and he was a veterinarian, so he knew what he was talking about), so if you do move in, just don't bring any pets. You might end up having them leap to their death from the upper floors, and not just to get away from your taking them to the vet!

Now we must head north on Pennsylvania Street, beginning the last leg of our circle back toward the capitol. Along the way you'll be passing some beautiful houses, so make sure you pause to admire them.

On the southwest corner of 12th Avenue and Pennsylvania Street, you will find two mansions, the David Dodge House and the home of Joseph Gilluly. Clearly, they were joined together at some point in the past. As it happens, that was in the 1930s, done so in order to create a hospital. Today, this marvelous edifice is known as the Pennborough.

You will probably be able to pick out the two original mansions in the overall whole. There are some beautiful units within, with details that attest to the level of wealth that was once the norm in architecture. I am not sure where the ghosts in this building come from, but I suspect they date from the time of Dr. John Tilden, a quack who did not believe in the idea that there are little things that you cannot see that might make you sick (i.e., germs). He thought that all illnesses were variations on a theme, that theme being something he called toxemia. He even wrote a book on the subject, giving advice to people on how they could cure a variety of illnesses that ran the gamut of headings, from halitosis and balding to cancer and tuberculosis. Of particular interest, to illustrate how off the mark this guy was, is his

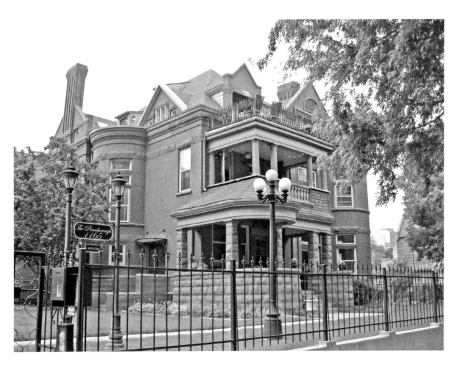

The Pennborough is the amalgamation of two mansions that were joined together in the 1930s. Shoddy medicine was practiced within its walls when they were made into a hospital, and the residences within the building still carry traces of a doctor's malpractice.

advice to pregnant women. He stated that the placenta is the most perfect filter known and that it will block out any harm from coming to the fetus. So, pregnant mothers, smoke opium all day long, drink three gallons of whiskey before bed, eat nothing but olives and take injections of whatever you might like; your baby-to-be will be just fine.

Yikes! No wonder the place is haunted!

One day I was giving a tour of the neighborhood and a lady was coming home and asked what we were doing. I am sure, by this time, you are able to imagine how the conversation went, all the way down to my blinking. She invited us in to see her place (the main floor and basement of the northern building), and it was truly a splendid place to tour. She concluded with the haunting of her residence. Her daughter's bedroom was in the basement, and the daughter would continually tell her parents that she would hear footsteps on the floor above (the main floor), even when she knew that no one was in the house. Her parents did not believe her, crediting her story to an active imagination, until the young woman went off to college and

the mother was in the basement herself one day. She knew no one was in the home and heard heavy footsteps on the ground floor above her head. Thinking someone might have broken in, she made her way to the main floor only to find that no one was there. Her daughter's recounting of the same phenomenon returned to her mind.

On another occasion, a colleague of mine was giving the tour when the lady who lived on the second floor of the southern building chatted briefly with the group. She did not invite them in (drat!), but she did mention that she had a ghost in her kitchen that had a peculiar fascination with opening the refrigerator door and leaving it open, which led to a lot of spoilage if the owner of the house was not home to catch the door hanging open.

Ever since I have been giving this tour, there has been a unit for sale at the Pennborough, so if you need a place to live, this could be the place for you! You might find more folks living in the place with you than you think!

On the northeast corner of the intersection of 12th Avenue and Pennsylvania Street, you'll find the stunning Dunning-Benedict Mansion, built in 1889 by the architect William Lang for Walter Dunning. Attorney Mitchell Benedict bought it in 1898, and then it was bought by Walter Cheesman upon Benedict's death. It was within these walls that Mr. Cheesman reached his own death. He was living in the house temporarily while his future home (today's Governor's Mansion) was being built. Although ghost stories for this building are harder to come by (I have been invited in numerous times, but none of the folks I have spoken to within has experienced anything other than charm over the building's architectural details), the building does relate to one place that is notoriously spooky—a place that bears the name of the man who died within its walls, Walter Cheesman. Cheesman Park carries his name and is a few short blocks to the east.

Too far for our walking tour, but I will give you the dirt on the place just the same. Speaking of dirt, all you would have to do is dig down a little— maybe about six feet under—and you would find something more than just dirt in Cheesman Park. Just remember that fertilizer comes in many forms. What am I talking about here? Let me tell you.

It deals with the Denver Botanic Gardens. I used to volunteer there every month. While I was there, I was asked to write a haunted tour for the gardens to offer to its members. They said there were a number of spooky things going on within the buildings, so I toured around, met some folks and heard their tales.

The main building of the gardens, located just to the right as you enter the front entrance of the facility, has the gift shop, meeting space, classrooms,

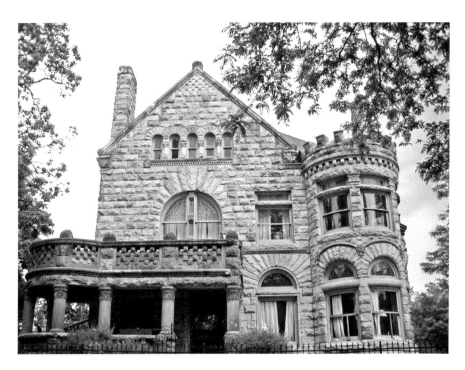

The Dunning-Benedict Mansion has offices on the ground floor and residences upstairs. Though many have walked its halls, its most famous resident is not only known for having died there but also for having given his name to one of Denver's finest parks. Today, Cheesman Park may be found about eleven blocks to the east, complete with trees, fountains and unclaimed corpses.

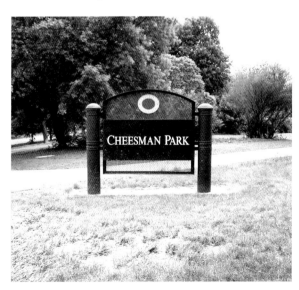

Cheesman Park, named for water baron Walter Cheesman, once served as Denver's first cemetery and is said to be haunted by the ghosts of those disturbed during the transformation from graveyard to park.

offices and an arboretum. When I volunteered there, I did my work in the upstairs offices, but the haunting stories, for this building at least, deal with the classrooms in the basement, creatively called Classroom A, Classroom B and Classroom C. The teachers for the classes offered by the gardens are in there quite often, as you might imagine, and have seen floating clouds of undulating darkness make their way through the air, like writhing oil slicks.

You see, the site of the Denver Botanic Gardens was once the Catholic cemetery for Denver. To the west, what is today's Cheesman Park was the Protestant cemetery. In the 1890s, the Protestant cemetery was decommissioned, and most of the bodies were moved (more on that in a moment). The Catholic and Jewish cemeteries were closed for new interments by the early 1900s, and they were decommissioned in the 1950s and 1960s. Most of the bodies were removed, but not all. Dig, Fido, dig!

One of the other haunted aspects of the Denver Botanic Gardens just happens to be my personal favorite mansion in the whole city of Denver, the beautiful Waring House, located at the northwest corner of 9th Avenue and York Street. It houses some of the garden's administrative offices, and during my time designing the haunted tour that I gave, I was allowed access to the building's unusual ghost repository. In one of the offices, there is a secret door that leads to a very small room. There is a window there and a narrow wooden staircase climbing steeply upward. The stairs come out on the upper floor in what was once a bedroom.

Maybe these were stairs for the servants, because in the old days the house's owners probably didn't mind if a servant fell down the stairs and broke his or her neck. Anyway, the stairs are not used today for anything of consequence, but it's not for the reason one might think. It doesn't have to do with the narrowness and relative lack of safety to be found on those stairs. No, it's the fact that opening the stairs awakens the ghosts in the Waring House.

Yep, you heard that right: "opening" the stairs. You see, these stairs are more than they seem. If you reach down by the floor, you may actually lift the stairs upward, like a garage door, revealing a secret passage beneath.

You might think that having access to a secret passageway would be the coolest thing ever, but in this case it is not, because while the Waring House does not normally seem haunted, that is only because the ghosts are generally asleep. For whatever reason, the ghosts in this lovely mansion remain quiescent unless someone opens the stairs. This awakens and agitates them. Following these very infrequent stair openings, the house will be beset by numerous strange sounds, things moving without anyone being there and

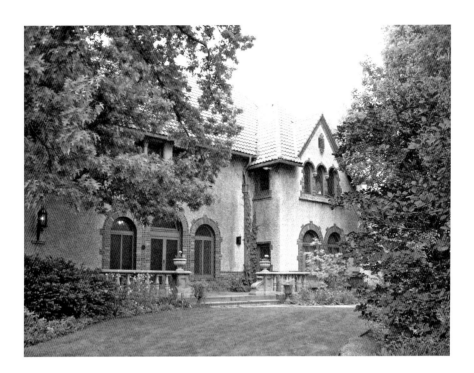

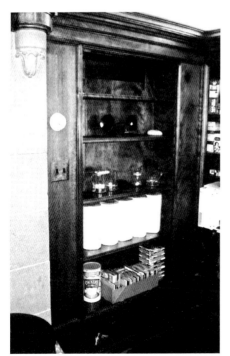

Above: The Waring House, which today serves as some of the administrative offices for the Denver Botanic Gardens, stands at the corner of 9th Avenue and York Street. The most beautiful mansion in Denver, it is home to spirits and secrets.

Left: This bookshelf in the Waring House is used for supplies for the office staff nearby. The bookshelf is more than it seems, however.

Above, left: The bookshelf is also a door to a secret room within the Waring House—and a ghost repository better left alone.

Above, right: Those viewing this window from the outside would not know that it leads to a secret. The sunshine that pours through it illuminates a room unknown to most every passerby and a hidden staircase that conceals an unexpected capability.

other disturbing poltergeistesque activity. No one sees anything, but there's no denying that someone is there. The activity continues for several weeks, gradually diminishing until the ghosts settle beneath the stairs once more, in quiet repose until the next time that someone lifts those narrow stairs. It's no wonder they are rarely used.

It's unlikely you will get to go into the Waring House, since it does not have a public face, and even if you did go in there, it's unlikely you will get to see the stairs, but my diligent (if decidedly uneager) ghost hunting has revealed the truth for my discerning readers. Next time you are by the Waring House, just keep in mind that ghosts are asleep within its cobwebbed recesses.

As for Cheesman Park, I have heard many stories about its being haunted but have yet to meet anyone who has actually experienced anything there except being startled by highly exuberant sunbathers. If you have had any

Above, left: These stairs, viewed from the access point at the bottom, are actually hinged and may be lifted up, allowing access to a concealed chamber. Few open the stairs, however, because doing so disturbs the spirits ensconced within the recesses beneath.

Above, right: The secret staircase ends in a door in an upper-floor bedroom, now an office for the staff of the Denver Botanic Gardens.

real experiences with the disturbed spirits of those who once resided beneath the grass, let me know. I would love to have that story to add to my repertoire.

In case you think that Cheesman Park might not be that haunted, despite being a former cemetery, let me offer a few more tidbits to titillate your palate. You might wonder what happened to all the bodies beneath the grass and tombstones when the cemetery was transformed into a park. First, the city asked folks to have their loved ones moved to Riverside and Fairmount Cemeteries at their own expense. After those who were willing to tackle this had done so (I hope they hired someone for the job!), the city was faced with taking care of the dirty chore. So, it did what any city would do back in the old days when faced with something unpleasant: it contracted the job out to someone else. That someone was a man by the name of Edward McGovern, an Irish fellow.

Corpses of Capitol Hill

Above, left: Rarely opened, this doorway leads to additional offices downstairs.

Above, right: Those who have trodden on these narrow stairs would never know that there, just under their feet, the spirits of departed souls lie sleeping.

Unfortunately, Mr. McGovern was a little less than stellar in the application of his duties. He and his crew were found to be treating the bodies quite disrespectfully, separating pieces and not putting them back together (if they got buried at all) and even stealing some of the grave goods found with the corpses. There was even discussion of somewhat meaty bodies being shoved into boxes too small for them, which led to "the juices of the dead" leaking out the seams of the miniature coffins. A local newspaper, the *Denver Republican*, published a scathing exposé concerning Mr. McGovern's doings in the park. It was entitled "The Work of Ghouls" and noted:

> *The line of desecrated graves at the southern boundary of the cemetery sickened and horrified everybody by the appearance they presented. Around their edges were piled broken coffins, rent and tattered shrouds and fragments of clothing that had been torn from the dead bodies. All were trampled into the ground by the footsteps of the gravediggers like rejected junk.*

As you might imagine, Mr. McGovern was fired. Despite being exposed in this fashion for his callous treatment of the dead, Mr. McGovern returned to his normal profession without any real diminishment of his clientele. Yep, you guessed it. Mr. McGovern was an undertaker.

Finally, the city placed a moratorium on the final move from cemetery to park (dare I say, a deadline! Ha!). Any bodies that were not recovered by families would be left there. Today, Cheesman Park still holds between two and three thousand bodies beneath the surface. The cemetery locations to the east hold fewer, but the area that served as Denver's first cemetery is riddled with those left behind in their first resting places.

If you don't believe me, consider this. In 2010, when the City of Denver was doing some work in the park digging a new irrigation system, four skeletons were unearthed. Found near the pavilion, the bodies were reinterred in other cemeteries. The Denver Botanic Gardens, in building its new parking structure, found and reinterred one body as well.

Such disturbances of a person's final resting place, as well as the horrifically cavalier treatment perpetrated by Mr. McGovern and his crew, would surely make for a number of restless spirits. So if you make your way to Cheesman Park someday, be warned!

For now, we continue north, crossing 13th Avenue, until we come to the Molly Brown House Museum, 1340 Pennsylvania Street, a wonderful example of Queen Anne Victorian–style architecture that bears an erroneous name. That's right, her name wasn't Molly; it was Margaret. Witness the power of Hollywood, creating a legend that's been truly unsinkable.

Although I usually point out the museum on my tours, I did not have any haunted stories about it until one evening when I was giving a tour. Now, you might be thinking that someone opened the door, asked me what I was doing, heard I was doing a haunted tour and then invited me in; that's certainly how it's been so far! This time, however, I was doing an architecture tour of the neighborhood, and after discussing the house's architectural features and some of its history, a participant drew alongside me as we continued on our way.

"I used to work in that museum, you know. For more than twenty years."

"Really!" Small talk, small talk, small talk, then, "Out of curiosity, do you know of any ghost stories concerning the Molly Brown House Museum?"

> *Why, yes! They're not particularly scary, but I am not the only person who experienced these things. Docents, other staff members, even visitors have had the same things happen, so I am confident in sharing. There's*

Corpses of Capitol Hill

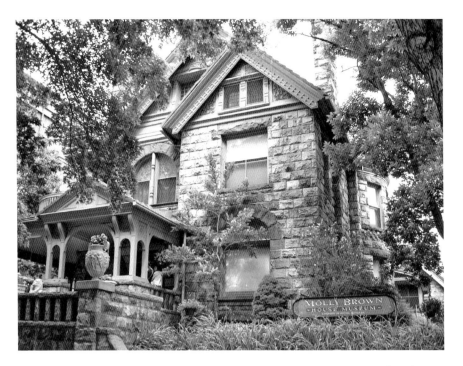

The Molly Brown House Museum, named for Denver icon Margaret Brown, offers visitors a chance to see the glories of the Victorian era, as well as its eponymous heroine.

a rocking chair upstairs that one of the ghosts in the building likes to sit in and use, rocking back and forth. The chair usually rocks when the house is quiet, such as before opening or after closing. On a number of occasions, when I would be making my way through the house to turn on or off lights, change the location of the blinds, that sort of thing, I would catch the rocker doing its thing, and it would always start to slow down right away, as if caught in the act somewhat ashamedly. Also, you may not know that Margaret's husband, J.J. Brown, was a famous fan of cigars. Though no one has been allowed to smoke in this house for decades, and it has been very well cleaned, there are many instances when people will report smelling cigar smoke in J.J.'s study. It is such a distinctive smell, you know.

As I would learn a short while later, smell would feature heavily in another Capitol Hill horror story, one much more memorable and chilling than good old J.J. enjoying a stogie for all eternity. As you read on, continue making

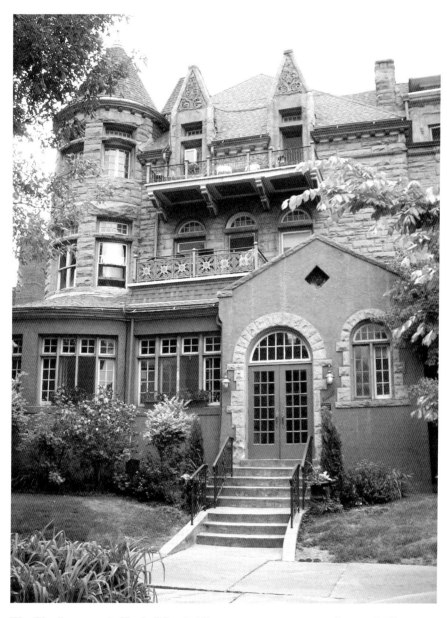

The Charline, a castle-like building holding numerous apartments, houses the Denver version of the fabled will-o'-the-wisp. Those who hear the alluring call are warned not to follow.

your way north on Pennsylvania Street before we begin heading westward once more. We have one more building to see before we return to the capitol.

In a few moments, you will come to a huge and ornate apartment complex on your left, on the west side of the road, known as the Charline. It is almost like a castle, most folks would agree, and now it serves as multiple apartments. The exterior of the building is quite fine, the inside a bit dismal and forbidding.

One day, I was walking past the building with my tour group, telling the folks about the history of the building, when a fellow came home on his bike.

"Hey, what are you doing?"

"I'm giving a haunted tour."

"Well, come on in. I live here. I can let you see the hallways, at least. This place is really creepy."

Blink blink blink.

"Okay!"

So we went into the main body of the building, though not his actual apartment. I suspect his apartment would have been a messy place, judging from the guy's overall appearance. Just as he had said, the place was kind of dark, with very heavy walls, odd angles and long hallways. It would have been the perfect place for a ghost story or a murder. Since we had all been talking about ghost stories for about two hours by this point, we were well in mind to find the place extra ominous. One of the ladies I was with asked the fellow if he had seen any ghosts during his time there.

> *I have never seen anything, no, but I have heard lots of stuff here. I frequently hear voices in the hallway when I am coming in and out, even when I can see that no one is there. A few times I have waited to see if anyone comes along, or if the voices get any closer or if I can understand what they are saying, but it's always just out of range, I guess is how you'd say it. It's like the voices are teasing me, or maybe they are shy. Some of my neighbors have heard the voices too, but no one I have spoken to has any idea who they might be. The strange thing is that the tones are kind of enticing, like the voices are trying to lure me somewhere. I've never been brave enough to follow them, because I have always been afraid of what might happen. Maybe I would end up somewhere other than the hallway of my apartment building.*

With thoughts of will-o'-the-wisps filling our minds, we left the Charline to head back into the bright sunshine of day. We felt better about being

outside, and one of the folks on the tour suggested that the man himself had been a little iffy on the ghost versus living person scale. So, if you are taking this walking tour and have someone invite you inside the Charline, just make sure you take a friend; ghosts wear many guises!

Now, as we head back to the capitol, our tall and shiny starting location, you may wish to walk down Colfax, known by *Playboy* magazine as "the longest, wickedest street" in the United States. There are all kinds of ghosts along Colfax, though most of them are still living. If you think Colfax is going to be too much for your tender sensibilities to handle, you may return to 14th Avenue and walk west toward the capitol. Whichever way you take, let's finish up with one last ghost story from Capitol Hill to round out our day.

When I first started learning about the world of the supernatural, I thought that ghosts were something that you saw or heard. I did not realize that there are also, quite commonly, ghost smells. No, they are not always the smell of rot or something equally unpleasant. Sometimes they are olfactory reminiscences, such as J.J. Brown's cigars in the Molly Brown House Museum. Sometimes they are the enticing scent of violets carried on the breeze. Enticing, yes—unless you know what the delicate odor of these sweet purple flowers portends for the ladies of Capitol Hill.

In the spring of 1901 the gaily dressed dames of Denver's finest neighborhood were reduced to a state of paranoia and dread, brought there by the powerful and unforgiving hands of the Capitol Hill Thug. The Thug would sneak up behind solitary ladies as they walked through the quiet streets at night and strike them on the back of the head. Sometimes he would use the butt end of a pistol. Sometimes he would use a rock and other times the appalling brutality of a long board with nails in the end. His motives were not money or mating, merely misogyny. Sometimes he would strike the ladies two or three times, sometimes dozens of times, unparalleled fury carried in each blow, leaving some women raving, some women dead.

As more information came in about the Thug, the police thought they would have an easy time of catching him based on some feedback they had gotten from some of the survivors. Several of the ladies reported that their assailant had a peculiar and very distinctive smell: violets. Now, at a time when people didn't have as common access as we do to bathing, deodorant and indoor plumbing, using perfumes, colognes and other eaux de toilette was a way of keeping one's natural and noisome odors from being such an assault on the nose. Still, there would have been scents worn by men and others worn by women. Gardenia, rose, jasmine and violet would have been

well-known elements of the feminine olfactory palette but certainly would have been unusual on a man. Even today, floral scents are not the first choice for most fellows, so in 1901, this was a big piece of information, and the police expected to capitalize on it.

Perhaps the noses of the police were not sensitive enough to follow the violet trail. Perhaps the Thug feared getting caught should he continue. Maybe he died or moved away. Whatever the reason, the ultimate outcome was not a fitting one, for the Capitol Hill Thug was never brought to justice. His legacy lingers on in Capitol Hill, however. How do we know? Well, the nose knows.

The police, in an effort to glean more information about the Thug, produced a map. It was a guide to the locations where the attacks had taken place, made in hopes of finding some additional clue. Wherever an attack had taken place, the newspaper placed the image of a fallen Victorian woman (not *that* kind of fallen) sprawled out in her large hat and voluminous dress. When I first saw the map, I thought the effect somewhat comic, though I soon sobered, remembering that each stylized symbol represented a brutal attack on an unsuspecting woman.

Over the years, this tour route has gone through some rewriting, some tweaking here and there. On three occasions during our many years giving this tour, some of my colleagues and I have passed through spots on the map where the Thug perpetrated one of his heinous attacks. Most of the time, the group noticed nothing in the realm of unusual smells. Three times, however, the Thug made his sentiments known through the presence of a strong floral scent, a scent that could be walked into and out of as clearly as moving from one room to another.

To be fair, very few people today would necessarily be able to identify the smell of violets from some other similarly floral scent. I know I couldn't. Also, someone might have gone by wearing perfume or been using incense nearby or any other countless possibilities. That the smell should come so strongly only in locations where there had been an attack, however, as well as the unease felt by the female members of the tour group, has led us to conclude that the Capitol Hill Thug is alive and well, spiritually speaking, and still staring hatefully at the back of women's heads from the other side. Ladies, if you are making your way through the neighborhood and smell something like violets, be warned of what you might find if you turn around to see what is there.

By this time you should be back to the capitol, so we must close our tour of Capitol Hill. I end this chapter with a piece of poetry used by many to

close out their lives. As a fan of cemeteries, I have toured many around the country, in almost every state, and the tombstones within them offer many insights into the lives and history of the area. I have frequently found this poem on the tombstones of old, sometimes with slight variations. So, in the spirit of honoring the spooks of Capitol Hill, both ignoble and otherwise, a poem from many centuries past:

> *Behold my friend as you pass by*
> *As you are now, so once was I*
> *As I am now, so you shall be*
> *Prepare for Death and follow me.*

CHAPTER 2
A LIFE WITH GHOSTS

At what point do you stop being afraid of the dark? I used to be afraid there were monsters in my room at night, once the lights were out, so I hid my head under my covers. Then one day, I realized I had not been hiding my head under the covers for quite some time and that my fear of the dark had been long gone. I tried to recollect precisely when and why this had happened but could not. Somewhere along my growing up, I had concluded there was no reason to fear the night.

Not all have reached the same conclusion. Among us are those whose connection to the world is more profound, whether they wish it to be so or not. Perhaps it's a gift, a sight beyond the daily visions before us. Some would call it a curse, and it follows them through their lives. So we come to a long life in association with the many worlds around us, the life of a girl named Ivy. In hunting for the ghosts of Denver, I had the extreme good fortune of being able to interview this remarkable woman, and I share her experiences with you here.

Now in her early sixties, her many memories of Denver's ghosts stretch back to a time when her age could be listed in single digits, and they are no less evocative for the time elapsed. It began while she was visiting her grandparents on their farm near what is now the intersection of Simms and Belleview. Today, this area of southwest Denver holds the standard appearance of suburbia, with numerous houses of a half dozen designs, large stores found across the nation and the uniformity we have all come to draw comfort from or revile, according to our preferences. At the time,

however, it was a farmland stretching for many miles. The foothills rising to the west made the first steps upward from the prairie, yielding to the towering presence of Mount Evans beyond. To the northeast, the spires of Denver's skyline, reaching past the twenty-story mark at that time, glittered in the night sky. Ivy enjoyed the visits to her grandparents' farm, with its many diversions, the novel smells and the large rooms with equally large windows. Her bed was not that of a child, consigned to a dark space in a basement or the back of the home, but a large and solid creation of the past, durable and comforting. Ivy enjoyed the sensation of enormity the bed afforded her. When the lights were out, however, the dark was darker than back home, the silence more complete. The large bed, she thought, would protect her from any monsters that might come. Nevertheless, on many nights when the heat stifled breathing in this farmhouse lacking air conditioning, she hid her head beneath her covers in order to fall asleep.

It was there, in that bed, that the presence she would eventually dub "the Thing" first became aware of her, and she of it. She awoke suddenly one night, her instinct telling her to listen. She did not know why she had been pulled from slumber so forcefully, could remember no dream, but her racing heart told her that something was different, something was not the same. Was her brother creeping into her room to scare her? Had she heard an animal outside the open window? In the darkness, her eyes were pulled to the doorway. She could not see it but knew the doorway stood slightly ajar, held in place by a rock so that it would not close, allowing for any cooling breeze to pass through the room. The door was open. She knew it was open. It was always propped open on summer nights. This night, however, it was more than merely an open door. It was an open mouth, beckoning: "Come."

Shifting, she put her bare feet down onto the wood of the floor, felt the grains of sand and dirt from the day. She passed silently through the doorway, down the hallway and into the kitchen, where the cool tiles sent a thrill through the naked skin of her feet. Screen door, unlatched, she passed into the night, the smoothness of the sidewalk beneath still warm with the energy of the day. The moonlight and starlight illuminated the motionless yard, the gate at the end of the sidewalk, leading into the impenetrable night.

Over the years, Ivy has never lost the conviction that she would have been lost forever had she followed the ghostly command and gone walking into that darkness. The flavor of the fear that bloomed within her that night is one she still remembers. Something was waiting for her out there in the darkness, some awful presence or creature she could not define. As odd as it

sounds, though her fear of what lay before her was insufficient to break the power of its call, another fear may very well have saved Ivy's life.

A thought percolated into her mind then, that she would get in trouble for leaving the house and wandering in the dark. The lane beyond the gate fairly beckoned her on with assurance that this would not be so, but Ivy's fear of her grandparents' reaction, the anger of her frequently unkind grandfather, dispelled the tug like cold water to the face. "At that point in my life, the thing I was most afraid of was my grandfather. In my mind, he was worse than any werewolf or monster or anything else my childish mind could imagine."

Suddenly shivering, she moved back into the house as quietly as she could, not stopping until she had buried herself beneath her disheveled sheets, sticky with sweat, shaking.

> *I did not remember that following morning what had happened the night before, until my grandmother asked me and my brother if one of us had been up in the night. With my grandfather glowering at us over his breakfast, I admitted to nothing, but I was also silenced by the flood of memory rushing over me. I did not come to any conclusions then. I was only nine. I didn't know what to think except that maybe I didn't like being out at the farm so much after all. It wouldn't matter, though, because soon our annual summer stay with my grandparents would come to an end, and we would be back in the city, back at home. I wouldn't need to worry about whatever had been out there, in the darkness. I was too young then to understand that a particular place doesn't always matter. Sometimes, the things we come to fear will follow us.*

A few years passed without event. Between wakefulness and sleep one night, the thirteen-year-old Ivy noticed a whooshing sound coming faintly to her ears. She felt an unreasonable dread blossom within her and started to rise, or at least attempt to do so. She was paralyzed, no movement possible at all, and the sound grew more distinct, low and gravelly, reminiscent of a growl, a low hum like a radio turned down. There came a voice. It murmured beside her ear, incomprehensible at first, gradually becoming clearer. The words promised Ivy that she would not escape.

> *I knew it was the Thing. I was paralyzed, unable to move any part of me at first. I let out a horrible scream, and my mother came running into the room. I was able to talk and begged her to help me, to stay with me, that the Thing was there and was holding me. My mother didn't believe me,*

> *thought I was trying to trick her, and told me to go back to sleep and left, turning the light back out. Then I heard the growl coalesce into words: I will never let you go.*

Determined, Ivy fought to break the paralysis that gripped her. It seemed an eternal struggle. Finally, she felt a sensation like myriad fingers tickling her skin, pulling quickly away, and her body was again her own. She reached to the lamp on the table, almost knocking it over, and pulled the dangling cord. Light illuminated black ribbon-like things undulating near the ceiling, vanishing a moment later.

She did not tell her parents any more of what had happened, silently arming herself against the occasional return of these sensations. As middle school gave way to high school, Ivy found a curious dichotomy within herself: her love of the horror movies she and her friends would watch, echoed by the ghost stories they would tell at gatherings, and the irregular touch of unwanted and unwelcome fear that took place within her own room when the Thing came to visit. Ivy was never sure if she had opened her mind to the ghost in the first place or if the ghost had opened her mind for her. She only knew that, from that time forward, her awareness showed her glimpses from the other side almost everywhere she went.

> *Three friends and I drove to Red Rocks one summer night on the pretext of looking for the "Hatchet Lady." Maybe it was only an urban myth, but we were determined to believe each and every delicious bit. The park was empty and very quiet, darker than it is today with the lights of the city so much closer. It was a nice warm night. We drove up and around the curves and decided to walk behind the amphitheatre, so we parked, heading for the high rock formations. I saw it first, a glowing white ball of light on the east rock face, with no source for the light in the dark and empty expanse of the theater. It grew bigger and brighter, still with no source. We quickly determined we had gotten our thrill and raced for the car. We left in a hurry.*

As we learned with the Cresswell House, ghosts may be attracted to a location where energy is provided to sustain them. In Ivy, we learn that a person, even an entire family line, may be just as alluring to those too restless to lie quietly in their graves. Ivy's father was a mechanic, a man capable of doing much with his hands. He built the family's home, the house Ivy grew up in, and was a man of practical views when it came to things. Most anything could be reused. In his capable hands, most everything did get

reused. Even items as delicate as mirrors could find new life in his designs, showing the lives within to his perceptive daughter. Within the house, there was one mirror that was something more.

When Ivy first became aware of this particular mirror, it stood in her parents' bedroom with mirrored wings on either side that could be folded in. Ivy would stand with the outer mirrors angled toward her, seeing herself reflected into infinity. The middle section was later incorporated into a hall throne, with coat hooks on the wooden frame to either side and a drawer at the bottom for gloves. Ivy had always been enthralled by the mirror, feeling it somehow looked deeper than a regular mirror. It was in the guise of the hall throne that it first revealed the truth of her impressions. Within its depths, Ivy would frequently see a woman wearing a long, brown dress of fine cloth. Young, in her thirties, the woman was fine featured, with a mass of brown hair coiled into a bun atop her head.

> *I would usually only catch part of her in the mirror, as if she had been standing there regarding herself, as I had so often done, and my approach made her turn to leave. Many times I simply saw the back of her walking sedately away, sometimes just the bottom of her dress or a hint of movement. I could see the living room reflected in the glass, but she was never in the room as well, just in the mirror. Only once did she actually stop to look at me. We were in the backyard having a summertime gathering, for the Fourth of July, I believe, and my father sent me into the house to get something. No one else was inside. When I came in the back door, the idea of the lady just sprang into my head and I knew, I knew with certainty, that she was taking advantage of the quiet to stand in the mirror and gaze at herself, as she was doing all the times I saw her. I sneaked forward very quietly and peeked around the corner of the kitchen. I saw her. I always thought ghosts would be sad, but she was not. She was vain. She was admiring herself in the mirror. I didn't have much vocabulary then, but today I would call her haughty. I didn't get to stare at her long. My dad called out to me to hurry up, and her eyes shifted to mine in an instant. There was condemnation in her face, as if I did not deserve to look upon her. She was very beautiful, in fine clothing that I associated with images of the Old West. With a lift of her chin, she turned and walked out of the image, with no corresponding person in the actual hallway, of course.*

Ivy waited for several months, hoping to see the lady in the mirror once more, though her feeling that the woman had left forever was becoming

stronger. One day, casually, she asked her father about the mirror: Where had he gotten it? Was it a family heirloom? Did it have any history? As is often the case when digging into things that seem to promise great answers, the result was disappointing. Ivy's father had found the mirror in a salvage shop, in a stack of mirrors that had been wrested from furniture and places too numerous and too forgotten to name. There would be no tracing the mirror back to the lady who had in life, perhaps, regarded herself with approval and admiration one last time before meeting an unexpected death. Though the mirror stands in the same spot to this day, the lady has never returned.

This was not the only mirror in the house that did more than most mirrors do. Another mirror, dating from the mid-1800s, small of stature, being the size of one's face, also adorned Ivy's home. It had fine lines throughout its substance, the materials within slowly separating with age. Ivy and others in the home would see smoky gray clouds swirling in the mirror's reflection during more than one séance the family conducted. Should these ineffable forms be seen, those attending knew that someone had come to speak with them.

Séances?

Yes, séances. Ivy's family had carried on a very lively Victorian tradition, using Ouija boards, tarot cards and other devices to divine the messages sent to them from the other side. In Ivy, the family's interest had found its greatest concentration.

By the time she was twenty-two, she was married and had two daughters. When her parents moved to the mountains (for a little peace and quiet), Ivy and her husband bought the house where she had grown up. The ghosts just kept coming. It was during her twenty-second year that Ivy and some friends were sitting in the kitchen, discussing the paranormal. Her friends agreed really strongly that they would really like to see a ghost and not just experience strange events that merely crossed the fine line of the inexplicable. Ivy kept silent, not wishing to get any closer than she already had. Still, the words had been spoken, and once spoken, words don't get taken back. From her vantage point, she could see past the others to an area where several rooms came together in a large hallway. Two bedrooms and the bathroom led off this area. Stepping out of one of the bedrooms came an obliging ghost, answering the summons. His appearance was anything but welcoming, however.

> *I saw him coming through the closed door, his form like thousands of moving particles moving together to create his form. Though there were*

no colors to speak of, I could see patterns: a checkered flannel shirt, heavy trousers, simple suspenders. He looked over toward us and continued moving forward, jerkily, somehow wrong. I realized that his joints didn't always bend the correct direction. Sometimes his elbows and knees would bend in the opposite direction, like one of those paper scarecrows we used to hang in the school when I was young, where their joints are swiveling pins and you may arrange their arms and legs all akimbo. He lurched forward, as if struggling to make his body work, his eyes wide on his head that lolled from side to side with each horrible lurch. My friends heard me catch my breath, and they looked back where I was staring. They saw him, staggering forward and, mercifully, through the doorway into the bathroom rather than toward us.

The group raced to the spot and found it as frigid as a freezer, being able to move their hands into and out of a stark temperature difference. They found no sign of the ghost in the bathroom and all agreed that it had not been how they had expected a ghost to look. Why was he so jerky? None of them found a way to rationalize the broken form moving so clearly from one room to another. Ivy, already a believer, solemnly told her friends not to wish for such a thing again. The image of the man's broken form would haunt her dreams for long after that night of casual declarations, and the voices coming in response would as well.

A distinctly male voice began to call her name, sometimes waking her from full sleep, sometimes sounding nearby as she was moving around the house. No others heard it. Always the same voice, low and clear, without threat. Ivy came to the private conclusion that someone wanted to keep her aware that she was not alone. Did the voice match the horrific apparition? She was uncertain but felt some disconnect between the pleasant sound of the voice and the image that had rent the air with its broken motion. Had that been the Thing?

Not all of the spirits that revealed themselves to Ivy did so in her home. With eyes open to more than color and light, she saw much as she explored the city of Denver growing up, with friends and with her family. On one occasion, when Ivy was in the eighth grade, she learned that a group of her friends was going for a visit to a mansion in Capitol Hill that had belonged to Charles Boettcher Jr., at 777 Washington Street. His wife, Anna Lou, had committed suicide in the house in 1941. Now long abandoned, the girls were certain that this house would be just the thing for a little excitement. It was reputed to be haunted. One of the girls' mothers would drive, and they

wanted to know if Ivy wanted to go. The school had had a field day resulting in an early dismissal from classes, so Ivy had some stolen moments before she would be expected at home.

> *Our main goal was to check out a bathroom upstairs where a murder had occurred. At least, that is what we had been told. The story was that someone had agreed to remain in the house overnight, appearing in a window each hour so that those waiting breathlessly outside would know that the ghost hunter had not fled the premises. After three or four hours, the person failed to show in the window and was found murdered the next morning, felled by an axe, the corpse pooled in frothy blood in the bathtub. No one had been seen entering or leaving the house, and there had been no sound. As anyone who knows kids in middle school might imagine, the veracity of the story was not important. It was real to us.*

Ivy and her friends entered the house, finding a door open on the side. They reasoned that vagrants had used the house on many occasions to escape the elements. All was riches in ruin. The Boettchers were one of the great families of Denver's history and had many houses throughout the region. Though the furnishings had long since been removed, the overall opulence of the place could not be hidden beneath the grim decay; this had once been a palatial home indeed. Many of the walls had been burst open, revealing pipes and heavy wooden braces. The sunlight of late afternoon pierced the motionless dust like something invading a tomb. The wide wooden stairs, chipped and devoid of rug, squeaked in eloquent protest or warning. There was no banister on the stairway, and shards of broken glass crackled under their feet with almost every step. The teens thoroughly explored the upper floor, eager for any talisman of their quest, finding signs of pigeons but no other indication of life. Disappointment began to rise within them. Eventually, in a bathroom now devoid of tub, they found something gruesomely akin to blood, smeared on the walls in long sweeps, across the broken sink, a dark and foreboding rust color. Each girl crooned in horrific enjoyment at the discovery, soon deciding that they had had enough. They moved to leave, retracing their steps through the disturbed dust toward the stairs, the only way they had found to return. Huddling closely together, chattering animatedly, they were not prepared for what happened next.

Behind them, a piercing burst of laughter transfixed them. As one, they turned to find a pasty figure at the top of the stairs, a mere six feet behind them. He was dressed in the finest of clothing, with a long black cape, as if

he merely awaited their departure so he could make his way to some festive event. His face belied the commonplace appearance of the clothes, however, his mouth askew, issuing forth a grotesque laugh, his eyes bulging outward hungrily. With a sudden silence that seemed louder than his laughter, he moved forward a step. The girls stood paralyzed. In a whisper that they heard readily, his voice high and fluting, as if carried on racing winds, he said, "Did you enjoy your stay?" Though the voice was almost comical, there was nothing humorous in the face that spoke them. Accusing eyes burned into the girls, and then the laughter began again. Like shattering glass, their paralysis fell away. Fueled by fear, they raced from the house in hysterics. The mother, who had waited outside, shuffled the girls into the car quickly, unable to make any sense of the chaos of words, knowing just that something frightening had happened. Only as the entire neighborhood faded from view were they able to calm their jangling nerves.

> *I've never forgotten his appearance: very tall, very thin, pronounced widow's peak and his eyes leering at us. We had no explanation. We never went back there. After a few years, it didn't matter. The house had been torn down, and I hope the ghost went with it, or maybe he was finally able to leave for his party. Looking back, I really had no idea that I was looking into another era. So many of the great mansions of Capitol Hill were being summarily demolished to make way for parking lots and high rises. I'm assuming the ghosts went down with the ship. The site of this old mansion is now the Governor's Park Condominiums.*

Although Ivy is clearly the most attuned of the people in her family, she is not the only one to have experienced something beyond the grave. Her daughters have had encounters within their childhood home, the same home in which Ivy herself grew up. Awakening one night, lying on her side, one daughter looked off the side of the bed not into the darkness of the hallway but into the glowering eyes of a crone, almost nose to nose. The child clamped her eyes shut and froze, listening, terrified. She heard the swish of cloth and creaks from the nearby stairs. When her bravery finally returned to her, she opened her eyes to find the scraggly-haired woman gone.

The girls, Marie and Elaine, had all the normal tribulations as they entered middle school. Inviting some of their friends over for a slumber party, some of the not-so-nice girls in their school heard of the event and insisted on being invited as well. Not wanting to be mean and hurt anyone's feelings, they acquiesced.

During the course of the night, Ivy, the girls' mother, was brought in to serve as the entertainment committee, chilling them with ghost stories that the young girls thought were fictional. Elaine and Marie knew not to disabuse their friends of their misconceptions. As it happened, the ghosts would take care of proving their own veracity.

The two particularly mean girls in the gaggle happened to be sitting on a small love seat in one corner. As Ivy spoke of unexplained phenomena, these two girls were giggling and whispering under their breath, being more and more outspoken in their disdain.

One of the other girls chided them, warning them not to make fun, to which the more outspoken of the girls retorted, "Why? Who's going to do something about it?" At that moment, the love seat lifted six inches off the ground and slammed down with a loud crack on the hardwood floor. Amid squeals, screams and sudden tears, the girls practically levitated out of the love seat and across the room. Ivy remembers, "Hysterical, the girls declared they would never enter our house again. No loss!"

Over the years, the Thing, that unknown presence that terrorized Ivy during her adolescence and early adulthood, gradually appeared less and less frequently. For a while, she would experience its unwelcome touch very rarely.

> *My children brought great strength to the house, and I think all of us together were able to keep it at bay to a greater degree. Now, however, my children have grown up and moved away, and I live alone. I'm getting more tired and not strong enough to keep it so far from me. Now that I am all alone, its visits have become more frequent again.*

Still, Ivy has reason to hope. In my interviewing Ivy, she described the world beyond as one of brightness and wonder that we only glimpse by the brilliant shadows and hues it casts across the landscape of our lives. She stated that it is not a place to fear, and with emotion palpable in her words, she concluded the interview with the most profound of incidents, one of love and hope. Rather than paraphrasing, I will share Ivy's words as she shared them with me:

> *Before Dad passed away, we made a pact that whoever died first would confirm life on the other side to those on this side. My parents lived in the mountains. After he died, my mom was all right on her own for a while, but after two or three years I moved her back to Denver. In the process of*

A Life with Ghosts

unpacking she came upon a "sand box," which my dad had given her one Christmas years before. It had a wooden frame, double-paned glass, about three by five inches, with oil and sand between the glass. When tipped, the sand would roll and form patterns and waves. Over the years, the oil had dried and the sand was hard packed on one side and corner. My mother had kept it because he had given it to her. Bringing it out of the box, she set it on the table without a thought.

Later, as we were taking a break, I happened to glance down at the glass, and I just gasped. There, written between the panes, inside the glass, was his name: Dave. It was in his handwriting as well, there in particles of sand.

I loved my father very much, and my mother did too. She was never the same once he was gone, alive but not living. We took pictures and cried, thankful for this simple message from this man whose love had been so powerful, such a positive part of our lives. We moved the box carefully, placing it where it would be protected. The next day, the word was gone.

He would return to us one time more. My mother went through four different kinds of cancer, conquering three of them, but the fourth one would

The name of Ivy's father, shown up in the sand and oil box he gave to his wife. Although the name would disappear soon after this picture was taken, both Dave's wife and daughter knew that he had communicated with them from beyond death.

be her last. We eventually moved my mother to the hospital because her care was becoming more than I could provide, not being a nurse. The doctors kept telling us that she could go at any time, but something kept Mom holding on. It was sad to see her in such pain, and none of us could cipher out her reason for staying.

One night I went over to my mom's house to water the plants. It had been a very hard day, and I was just spent. As I entered the front door, I saw the light blinking on the answering machine. I just felt a shiver pass right through me. Everyone knew my mom was in the hospital. The rational part of my brain knew that no one would be calling. She didn't have that many people to call her anyway. I pressed the button. It rewound, clicked and began to play, emitting static, crackles and dead air before a voice, distinct but very far away, sounded from the machine: "Hello, Old Darlin'."

My father was the only one to refer to my mother as "Old Darlin'," and it was his voice. I let my kids listen to it, and we all cried.

My dad also visited my son in his dreams at this time. My son was very close with my mother, and he was having a hard time accepting the inevitable. In the dream, my son described my dad pulling into the driveway in my parents' 1970s green Ford Thunderbird, a vehicle they hadn't driven in years. My dad got out and told my son, "It's time for your grandmother to go." And my son said, "But I'm not ready to say goodbye yet. She's still here." And my dad said, "I'm waiting for her. She needs to leave. I'm here to pick her up."

My son did not want to lose his grandmother, but he saw how much pain she was in, so about a week after he had had the dream, he told her of it. My mother was very angry. "Why didn't you tell me sooner? I've been waiting!"

She died the next day. The answering machine broke, and we lost the message, but it doesn't matter. I know that the universe is filled with forces of will both hateful and bountiful, and that there are times in our life when the fear or what lies ahead might bring us to tears. My parents are there watching over me, and one day they will come to take me across the bridge to join them in that beautiful light. When the time comes, I will take their hands again in mine and cross without hesitation. I'll be smiling through my tears.

Chapter 3
Beastly Ghosts on Inca

It's amazing how often you begin to stumble upon things as soon as you become aware of them. You know what I am talking about, don't you? Imagine the first time someone explains to you the meaning of the word "sesquipedalian." I mean really explains it to you so that you remember it. You will suddenly begin to see the word everywhere. You will wonder if it really had been everywhere before and you are only now just more aware of it or if, through some conspiracy of coincidence, the world suddenly seems to be crazy for the word sesquipedalian.

I don't have the answer for you, but I bet you know what I am talking about, even if you don't know the word sesquipedalian. It's a good one; look it up before you continue and maybe you'll see it elsewhere very soon!

I was in the store one afternoon, buying whatever it was I was buying that day. While waiting, a friend of mine called. Since the line was not that long, I answered but told him I would call him right back. Before he let me hang up, he said something like "I hear you're doing a haunted book! Ha, that's the funniest thing I have heard, you're going to have to tell me all about it, etc." to which I replied, "Yeah, who would have ever thought I would be doing a book about ghosts," or something to that effect and hung up the phone, returning to my mental reverie.

My thoughts were interrupted by the person in front of me, a woman who blurted out that she had a house that was haunted. She seemed uncomfortable to be confiding this information to me, like someone sharing a secret where she had some shame, but as we talked about it more, she seemed to warm up to me and the idea of being able to tell someone about it.

This is a good story to share, not only because I was able to interview the couple who experienced it but also because it is a good reminder that it is not only grand houses and grand neighborhoods that experience that chilling touch of something unwelcome.

Brinker and Stella are a nice couple. They got married and needed a place to live, so they chose a place in the Greater Baker neighborhood, closer to Santa Fe than to Broadway, thinking that the neighborhood was coming up and that their house would come up along with it. The street they ended up on was in need of some love, but it had lots of people who seemed very enthusiastic and friendly. They liked the place and saw it as a project; it certainly needed some help!

The front yard sat filled with weeds or barren dirt. The backyard was not a yard at all, having been entirely paved over with cement. The house itself had a strange upper story, not quite finished but not entirely unfinished either, and the main floor was an odd tangle of doors in confusing places and walls where there should be none. The kitchen alone had four different doorways from it, along with a stairwell, which meant it had very little counter space, but Stella and Brinker were game to give it a try, especially since Brinker was not afraid to work on things he had never done before, like drywall, plumbing and even rewiring things. So they set to work to make their first home the home of their dreams.

It didn't quite work out that way. At first, Stella thought it was just being in the new neighborhood that made her feel uneasy. Her husband was gone a lot for work and home on the weekends as much as possible, and though she had been able to manage sleeping by herself before, she was having greater difficulties than she had ever known. She kept hearing sounds from the partially finished space that composed the second floor, the upstairs that was largely empty of anything save dust.

When her husband was home, she got up the nerve to ask him to explore the upstairs a little more fully, styling it a "treasure hunt." Maybe they would find hints of the folks who had been in the house sometime in the past, she said. He went along with her evidently playful request, not realizing that she was looking for more than simple treasure. In a corner, they found typesetting blocks that would have been used for some sort of printing machine but nothing else of interest. What was missing was actually more compelling for Stella, for she was convinced she would see miniscule footprints in the dust. In the darkness of night, alone in her bed, she had been hearing skittering movement across the floor above her. Were the footsteps mice or maybe even a squirrel? Her conviction

that such animals were the source of what she had been hearing was severely shaken upon finding the dust completely undisturbed when they came into the room.

The next time her husband left Denver for work, the first few nights passed in silence and contented sleep. Then it began again—the quiet but distinct sound of small feet pattering across the floor of the level above her. Grabbing a flashlight and nerving herself to be brave, she stealthily climbed the stairs leading to the upper level and waited until she heard another spasm of movement. In one swift movement, she opened the door and thrust the flashlight into the space, for there were no working lights in that area. The movement ceased. Stella combed over every inch of the space with her light, seeing no indication of any four-footed presence, either in the flesh or in the dust that remained here and there.

Then, very quietly, she heard something behind her that made her throat catch: the sound of multiple small feet moving down the stairs and into the main body of the house.

> *It was like hearing dogs walking on a hardwood floor, the clicking sound. My parents have hardwood floors, and when the dogs would walk around, you could always hear that clicking, except that these sounds were softer, like they were coming from something smaller. The sound made me feel as if I had been tricked into coming upstairs and releasing something. The sounds were almost like mocking laughter. I was so afraid, I thought I was going to throw up right then. I got so cold that I was shaking.*

When she got down to the main floor, having closed the upper door behind her, she saw no indications of something that would have accompanied the sound. She nervously turned on every light in the house and searched thoroughly but found nothing.

Unfortunately, things got oddly worse after her nighttime excursion and evident release of whatever she had been hearing. She no longer heard the sounds at all, whether her husband was there or not, but she had the distinct feeling that something ugly had taken up residence in the living area of the house and, like the Pied Piper of Hamelin, was exerting its dreadful power on the living animals of the neighborhood.

> *It was horrible. We couldn't keep them out. When I had the door open, bringing in groceries, stray cats would race into the house. My husband's allergic to almost every animal on earth, but especially cats. It was almost*

> *impossible to get the cats out! They would hiss at us, hide behind furniture, scratch and bite. It was a nightmare.*

Cats were not the only animal showing a fierce desire to get into the house. Squirrels would bite their way through screens, mice found openings everywhere in the old house and every manner of insect began to invade the interior. "Especially spiders, and I really, really hate spiders," Stella explained. Most were benign, but not all of them. "We had spiders everywhere, even a couple of black widows. I found one behind the piano when we were moving it. I touched its web and looked, and there it was, as big as a marble. I could hardly sleep because I was certain the spiders would crawl over my face in the night. I can still remember the feel of the web on my hand."

Brinker didn't believe his wife at first, being the kind of person who is thoroughly grounded in scientific reality, but eventually even he had to concede that something very peculiar was going on in the house. They had exterminators out for the bugs and the mice, had the screens repaired and avoided opening the windows and did their best to keep the alley cats from coming into the house. "At least there were no dogs coming in," Brinker told me when I sat down with the couple to get the full story. "Or snakes."

Eventually, the couple moved from the house for a variety of reasons. One, at least, was based on the realm of human relations.

> *One of our neighbors was kind of difficult, especially once we started doing our landscaping and the plants started to grow. Weeds came up, too, once we started to water, and she seemed bothered by the growth, kind of a "weed cranky" woman. That was certainly part of why we left, but not all of it. No matter how many times we sprayed, no matter how many traps we put out, how many screens we went through, the place was under constant attack by a never-ending train of animals. When the rats started getting in and I awoke to something tickling my face that was a gigantic spider, that was it. We moved to a new house.*

Brinker and Stella kept the house, thinking they could eventually fix it up and sell it, enjoying the beastless life of their new home. The house on Inca sat quiet. After several years, they had saved up some money with the intention of making some changes to the interior of the house. They hoped to get it sold.

Beastly Ghosts on Inca

We visited the house very rarely, to be honest, and I suppose that was a mistake. When we got over there to do some measurements, we found the house was full of dead insects, everywhere. They crunched under our feet as we walked, and that was not the worst. There were dead mice everywhere too. One of the back screens was ripped and, we have no idea how, the window was open. In the back bathroom we found a squirrel curled up in the fetal position, dead and desiccated, and just outside the window was a dead pigeon. The place had a strange smell, too, and the air was so heavy in there. It was like the silence of someone who was unhappy being disturbed, having grown accustomed to having the untroubled run of the place. We weren't sure if it was a person's ghost or an animal's ghost or many ghosts or what, but we knew even more than before that something was there.

We ended up telling a friend of ours about what was going on there. A few weeks later, he surprised us with a piece of paper with strange patterns of lines on it. He said that we should make copies and place one of these copies on each floor of the house, that the symbol was a maze from which there was no exit. It would draw the ghosts into it, trapping them. We should leave it there for a month or so, then remove them and burn them. We were torn between humoring him and our own certainty that something was wrong with the place. Who were we to scoff? So we made copies and did as he said. We didn't go in the place again for two months, at least. When we came back in, there were no new animal corpses to be found, no new damage to the screens or other parts of the house.

When I removed the papers they felt dusty, which I guess was normal, but also very heavy. It was a creepy feeling. When I touched the first one, I felt angry too, inexplicably so. I started yelling at Brinker about something that had happened earlier that day, and he told me to place the piece of paper in a bag. As soon as I let go of the paper, my anger evaporated.

They burned the papers down by the South Platte River. Since then, they have had no problems with the house on Inca Street and have been working on renovating it, but Stella had this to say by way of conclusion:

You've heard stories about lost pets finding their way home from long distances? I just have the strangest feeling that whatever we caught and tried to burn away down by the river is still out there somewhere, trying to find its way home. I hope we are free of that house before it gets there. I don't ever want to go through something like that again.

Let's just hope that these restless and murderous spirits don't choose another house instead of the one on Inca—perhaps a house in another part of town currently serving as the home of an unsuspecting couple unknowingly counting down the days until the hissing cats and creeping spiders crawl into their lives, skittering claws in the night.

NOTE: At the point of the original interview with Brinker and Stella, they were willing to have the address of their home on Inca listed, along with a picture. They contacted me subsequent to the interview to tell me they had changed their mind, fearing folks breaking into the place owing to its reputation.

Chapter 4
Street Walking with the Dead in LoDo

Most people (in Denver, at least) are familiar with the part of town known as LoDo, the oh-so-hip name that is a shortened version of the much less romantic "Lower Downtown." During the great spasm of urban renewal that saw most of downtown Denver obliterated in the 1950s, '60s and '70s, this section of town avoided the wrecking ball by virtue of being so bad, so derelict, so decrepit that no one thought the area was worth tearing down, much less building up again. Some folks of vision disagreed, however, and with some fights and some finances, they ended up creating Larimer Square, a sparkling emerald risen anew from the despair that once held a grip like a vice on all. As Denver's first historic district, Larimer Square gave inspiration to many historic preservation efforts that would follow, and LoDo today owes much to that vision.

As you might imagine, these buildings are quite old, many dating from the 1800s, and old buildings are prime haunts. So we begin our tour with the Oxford, at 1600 17th Street, the oldest hotel in the city of Denver.

Built in 1891, the Oxford served to anchor one end of Denver's financial district, 17th Street. So much money moved along this street that it was known as the Wall Street of the West. If you walk the hallway between the bathrooms in the basement, you will see pictures of the building over time and publications extolling the building's luxuries when it opened. Unfortunately, times would not always remain so robust for Denver, and the

The majestic Oxford, Denver's oldest hotel, stands at the corner of 17th Street and Wazee and offers guests not only the finest in accommodations but also a number of very interactive ghosts.

Oxford Hotel would ride the fortunes of time, changing along with them. Its status diminished as the neighborhood around it did the same, eventually replacing much of its Victorian furnishings and decoration with the style of the 1950s. By the 1970s, the hotel was in need of a helping hand. At the end of the decade, it was closed. It was then restored to its former glory and reopened in the early 1980s.

Despite the changes to the building, inside and out, some of its permanent inhabitants remained, apparently unfazed by the outward trappings of their home.

When I first became aware of the Oxford Hotel's reputation, I had fairly extensive access to the building in pursuit of its ghosts and ghoulies. Over the years, however, the hotel has sought to distance itself from being known as a spooky roost, in favor of being known as a classic luxury hotel. Owing to this, my access has gradually diminished over time, but the stories I have gleaned endure. I share these stories with you along with some requests: if you decide to enter the hotel and have a look around, please be respectful of the fact that it is a place of business, which means limit where you go. Please restrict your movements to the areas open to the public. Be a silent observer. The ghosts are more likely to appear to you if you are silent, anyway.

The first stop on our tour is for the ladies, especially those who have been enjoying the varying libations of downtown. Yep, it is the ladies' restroom in the basement, with access at the base of the stairs that descend from the lobby. If you are a lady (or even if you are *not* a lady but are female, you'll still be on target), stride boldly through the doorway, asserting your lack of fear concerning the ghost that has watched you come into the room. If you are a gentleman (if you are *not* a gentleman, get out of the Oxford right now, because this is a fine establishment, and no unsavory blackguards are allowed within its walls), then politely ask one of the ladies in your party to see if there happens to be a lady in the room. Please remind the lady that, should there be someone in the restroom, she should not say things such as, "Hey you, get out, we are doing a tour." You think I'm joking, don't you? Nope, I am not joking. That happened once on a tour, and I had to hasten to tell the lady washing her hands that she could, in fact, finish what she was doing.

Anyway, once you have determined the room is safe and your admittance has been secured, admire the place for a moment. Notice the thoroughly modern sinks surrounded by thoroughly antique marble structures. These structures give you a clue as to what this room used to be. When the building opened, there were not many women travelers, so this was not a bathroom

for the ladies. It was a place for the men, a place any well-regulated hotel would certainly have.

That's right! You guessed correctly! How did you ever get so amazingly clever? Yes, it is the former barbershop for the hotel. One assumes they were washing coins somewhere else in the hotel, because there would not have been a spot for it here. No, this room was for making all the Dapper Dans even more dapper than they had been before they got to the hotel.

In the modern world, however, it is a ladies' restroom. That should not lead my gentle readers of the female persuasion to think that it has entirely lost its masculine presence. Quite the contrary; there is still a man within this room. He has never left.

When I first began giving this tour, I visited a number of members of the front desk staff, asking about what goes on in this restroom. Most of the time, nothing happens. If the ghost appeared every time a woman went in there, the hotel would close the restroom instead of using it. The appearance of the ghost is infrequent, but when he shows up, his manner is always the same. Picture, if you will, a woman in a bathroom stall, venting her bladder as we must all do, when suddenly, a man's face pokes up over the wall of the stall, looking down on her. His face is ruddy, covered in a grizzled beard, his hair abundant and bristly in tight curls, the whole of him, right down to his filthy fingernails, really in need of a bath. The woman, far from noting his lack of recent ablutions, however, is much more alarmed by having a strange man suddenly eyeing her while she's answering a call of nature. Sure, that kind of thing might be all in good fun at home with one's honey bunny, but it is simply not done in hotel restrooms (well, not at the Oxford, at any rate).

The woman might issue forth some expletives warranted by this situation. Most folks could imagine them, I should think. As the man lowers himself down and walks away, some women go so far as to open the stall door to continue pouring out their invective.

Many of the women who experience this frightening encounter have gone to the front desk to complain, which, according to the member of the staff I was talking to, leads to a mighty quandary. "What do you say to her? If you say something like, 'We're sorry,' she ends up thinking the hotel is unsafe. If you say to her, 'We're sorry that happened to you, but we can't really control it. That person was a ghost,' then she ends up thinking the hotel is unsafe in a different way. Either way, we kind of lose."

Over the many years of giving this tour, the fellow has never shown up on any of my visits (for which I am singularly grateful). I believe he enjoys the surprise of it all, and how startling is it to shock someone when that person

or group is talking about you? Not surprising at all, I say, so he has never shown himself. We don't know who this urocentric fellow is, but one day, ladies, you might get so lucky as to have him give you a thrill while you are seated. Keep your camera and some toilet paper handy!

Leaving the bathroom and turning to the right, you may proceed past the men's restroom (not haunted but possessing some truly inspiring urinals), up the stairs and into the Cruise Room. The Cruise Room opened to celebrate the end of Prohibition and the fact that no one—not one single person—had drunk any alcohol in the years since 1916, when Colorado had gone dry, four years before the whole country did the same. It is meant to look like a bar on a sailing ship, such as the most famous vessel of the time, the *Queen Mary*. Artistically, it is Art Deco through and through and (though I don't know from personal experience) is said to be Denver's premier martini bar. So unless the bar is not yet open or you are underage, head in, settle down for the libation of your choice, maybe order an appetizer and let me tell you a little bit more about the Oxford Hotel.

The remainder of the tour you will have to digest from the comfort of your booth in the Cruise Room, for the spots are off limits to casual visitors. The primary places we will discuss are Room 320, known as the Murder Room, the attic and the ballroom.

Of the three, the ballroom is the least haunted, so let's start with that. The parquet floor of the ballroom used to be the wood on the bowling lanes at the Celebrity Sports Center. Small world, right? When that marvelous building was torn down, the wood was recycled to the Oxford Hotel. Hurrah! The spectral visitors to the ballroom did not mind the change in décor, apparently, for they have continued to haunt the place in their own special way. As we discussed in the chapter on Capitol Hill, ghost smells are a known phenomenon among ghost hunters, and I was told that members of the staff have, on occasion, smelled cigar smoke within the ballroom, though no one has been allowed to smoke there in many years. Interestingly enough, I have twice had groups smell the cigar smoke in the ballroom, once after I had told them about the manner of the haunting and once before. In both cases, the only people able to smell the odor of cigars were the ladies in the group. In both cases, the ladies were able to move in and out of the smell, with a distinct boundary. Whatever game of cards these ghosts are lingering over must be really intriguing, and just imagine how high the pot must be by now! I hope somebody wins soon, because even the most riveting poker game would get tiresome after several decades. The ballroom, located on the second floor of the Oxford Hotel, is available for all manner of events, including weddings, receptions, meetings,

parties and anything else you might imagine. If you need a spot with a little something extra, this could be the location for you to rent, knowing that the room you have chosen may look empty before the first attendee arrives but there are, in fact, some guests who have never left it.

When I first started giving haunted tours within the Oxford, we were allowed access to the attic. This gracious gift on the hotel's part (since a member of the staff had to go with us) has had to be curtailed for insurance reasons, but we had several years of access and lots of enjoyment during our visits. The paranormal research organizations that came before us reported hearing voices on their recording devices left overnight (things like a little girl's voice asking the listener not to feel sorry for her and a rough, threatening voice telling the listeners they had better go to sleep) and sensing numerous presences within the confines of the attic, a veritable convention of incorporeal creeps. Once inside, I turned my guests loose to look around. Folks got numerous orbs and ropes with their cameras, these being, in many folks' estimations, the signs of spiritual manifestations present with the living. On two separate occasions during my tours, some chilling things took place.

Near a descending roofline, where the ceiling was far too close to the floor to have allowed any kind of ready access to anyone living, two ladies saw a set of boxes move silently across the floor, steadily outward. In addition to the shock of seeing the unaccountable movement, both ladies felt a great sense of foreboding. On another occasion, a woman walked by a dusty tabletop and looked back to speak to her friend, who she had heard walking up behind her. When she turned, she saw no one there, though she was certain she had heard the clear staccato of footsteps. In the dust of the tabletop, she saw the clear imprint of a hand, which had not been there when she had walked by even seconds earlier.

You might wonder what I experienced in the attic. The easy answer is simply this: nothing. I never explored it, not even once. Each time we allowed folks their fifteen to twenty minutes to explore, I sat myself steadfastly at the top of the stairs by the entrance and awaited their return. I suppose something could have come to me, but I had the feeling that it worked the other way. The ghosts in the attic wanted you to come to them; it's easier to pick people off in ones and twos than as a large group, you know.

Now, Room 320 is upon us to discuss. When I first learned about the Oxford Hotel and researched its stories, I heard that this room had been given the grandly graphic appellation the Murder Room. I am not sure who was murdered there or even when, but the ghosts in the room would seem to lead to that conclusion. Surely someone was murdered in that room; why else would the ghosts in there behave as they do?

Street Walking with the Dead in LoDo

According to the members of the front desk staff that I interviewed when my long and rewarding relationship with the Oxford began, nothing happens most of the time in Room 320. If something happened in there constantly, they would not use it as a hotel room. They would lock it up, make it a broom closet and rent it out to some whacko, any whacko who would consider sleeping there alone even though he knows it is haunted. No, most of the time, Room 320 is quite benign. Further, the staff at the hotel does not actually tell the person anything special upon handing that person the keys. If so, it would go something like this: "Oh look, you've been booked into Room 320! How spooky! Around here, it is known as the Murder Room. I hope you aren't afraid of ghosts. Do you have a will?" No, that sort of thing is never said, and to be perfectly fair, most of the time nothing happens in the room at all. Very bland. Very quiet.

When something does happen, it happens when it is a man in the room by himself. Not two people, not a lady in there alone—no, a man by himself in the Murder Room. Then, once in a great while, an evening of frolic and merriment takes place.

One of two things will happen. The less scary of the two (in my opinion) is that the man will be awakened in the middle of the night by a man standing at the end of his bed, cussing him out for contributing to the infidelity of a wife (i.e., the man in the bed has been sleeping with this man's wife, something that could well have led a jealous husband to commit murder) and telling him to get out. Most men do.

The other haunting is far worse, however, and I must paint the scene for you to appreciate it. If you open the door into Room 320, the first thing you will see is a small living room area with many comfortable furnishings from a bygone era and, just because we are in the twenty-first century, a large, flat-screen television on the wall. Go beyond the television, to the rear wall where the windows are, and you will find a small hallway leading to your left. Proceed down the hallway a few feet and you will come to the bedroom, the foot of the bed just before you and the bathroom to your left. The bed is large and comfortable, the room opulent and charming. Your eye notes with delight the large wooden headboard, complete with an inset brass plaque, almost as large as the headboard itself, with enormous letters reading out: COME SWEET DREAMS; THE HOURS OF SLEEP BEGUILE. The unsuspecting male guest might even entertain a fleeting thought that the hotel goes well above and beyond the call of duty to include poetry on the headboard in each room. What this unsuspecting male guest doesn't realize is that the hotel

does not include poetry on the headboard in each room. That distinction is reserved for Room 320.

The unsuspecting male guest goes to sleep, and little does he know that the hours of sleep are not the only thing in the room that may seek to beguile him. On those rare occasions when the room's ghosts come to interact, it is not always the man filled with diatribes who awaits. Sometimes it is scarier than that.

Picture, if you will, the man lying there in bed, sleeping soundly, dreaming of things men dream of, such as bacon, watching TV, bacon, sword fighting, bacon, hiking up Devil's Head and, of course, bacon. How peaceful he looks! Such repose! Then, so quietly, something begins to pierce the perfect tranquility of his slumber. A subtle clicking sound, and the repeated ruination of the cocoon of night, eventually enter his mind and draw him upward; someone is turning the lights in the bathroom on and off.

He awakens and puzzles over the lights in the bathroom doing something lights in bathrooms are not normally supposed to do. Why are the lights in the bathroom going on and off? Is there an electrical short? Is there a power surge? Just before he reaches full consciousness, just before he rises to examine the bathroom near the foot of the bed for some source of this strange occurrence, the lights go out, and once more he is in the encouraging darkness of his room. The whole situation is telling him to go back to sleep, lulling him, for the bed is comfortable, the covers warming and the man still fuzzy from the interrupted dream about something pleasant (probably bacon). As he closes his eyes to return to that happy dream, he puts the thoughts of the bathroom out of his mind until, a moment or two later, he realizes something else has changed other than the illuminatory habits of the room. He is not alone.

He feels furtive movement. The covers of the bed are being stealthily lifted. A moment later, he feels someone lie down on the bed, someone who is not there.

Perhaps it is the adulterous wife returning to the bed where she died, hoping to resume the interrupted assignation. Perhaps she just wants to cuddle and talk about her feelings (after all, the man was asleep). Either way, the man catapults from slumber into a state of full wakefulness, not interested in finding out the desire of this uninvited presence in his bed, and then his fright allows him to levitate from the bed.

According to the folks I spoke to on this subject when I first began my association with the Oxford, these men invariably come down in the middle of the night, some of them barely dressed, wide eyed and pale from their harrowing experience, demanding a new room. Graciously, the front desk

staff will comply. What else would you do if you ran the hotel? Demand satisfaction? For whom, anyway?

There have been two occasions that I know of myself when folks went looking for these ghosts in Room 320. Ivy (discussed in a previous chapter) once spent an evening there, opening herself to the ghosts that fill the place. The other occasion was partially through my own efforts, but before we discuss that, let's focus on Ivy's unusual encounter—unusual because the place does not normally interact with women.

Knowing of the Oxford's reputation in general and of Room 320 in particular, Ivy and a friend decided to rent the room out one Halloween night. You read her choice of evenings correctly: Halloween night. Clearly, she has gotten bolder as she has gotten older. She recalls:

> We had a regular camera with which to capture the anomalies. Several pictures turned out fuzzy or watery for no reason before or after good clear shots on the roll. We were able to get some orbs and ropes in our room. A digital camera we used caught many orbs too. I tossed and turned during the night and had disjointed dreams. Then, deep in the night, I awoke with a start. There was light in the room. Something was glowing in the bathroom, and though the light was low in intensity, its presence was unmistakable. The door closed slowly, almost shutting, then opened slowly once more. All the while, a kind of sickly white light, very large, floated there in the bathroom. No one was in the bathroom that I could see. Then, after several undulations of the doorway back and forth, like the ebb and flow of a tide, the light winked out and the door ceased moving. Darkness reigned once more. My friend was asleep beside me.

It would be years before I would learn of Ivy's numerous experiences. Long before I interviewed her, however, I had my own very distant brush with the room in question. Trust me, it was very, very distant.

One year I noted that Halloween would fall on a Friday night. Thinking that it might be a nice perk to be able to go into Room 320 as part of my haunted tours, I rented the room nearly a year in advance. I even paid for it when I made the reservation. The year passed, and as the night of mysticism and mayhem arrived, I had something extra to look forward to beyond just the tour. I had been contacted by a paranormal research group, and it had made arrangements to do a séance in the room after I finished my last tour for the evening and before some lucky fellow bedded down for the night, in Room 320, alone.

Do you imagine that the fellow bedding down in the bed beneath the beguiling headboard would be none other than the author? Well, if you do, then you have not been paying attention. My response to that suggestion was, and I quote, "Oh, hell no!" No, I don't like to be scared, and even imagining the situation was enough to make me quake in my sneakers. No, the fellow who would spend the night in the room was, as it happens, a colleague of mine who, as you might expect, experienced nothing but a placid night of sleep. Ghosts do not enjoy performing to an anticipatory audience, I believe, and so his night passed without event.

The paranormal group did have some fun with their séance, however. I heard from them that next morning. No apparitions, no manifestations, but they did get some excellent readouts from their computers. I don't precisely understand how it works, but each word one might speak has an electrical signature, and by reading the electrical currents in the air, ghost hunters are able to pick up on the words being communicated to them from the other side. I would love to tell you that the ghosts from the other side gave the names of those associated with the crime that purportedly happened in this room, along with dates, details and, of course, hat size. They did not, unfortunately, but they did do something with names. Over the course of the séance, the electricity in the room cycled through the names of those people within the room taking part in the effort to communicate with the ghosts, naming off the participants one by one.

Very eerie.

While all this was happening, I was peacefully at home, asleep in my bed. I am a sensible fellow, and that was the sensible place to be.

Thus we have almost concluded our story of the haunting of the Oxford Hotel. I hope you are done with your refreshment, for you have two more things to do: thank the kind folks in the Cruise Room for hosting you while you have read these pages and ask them about the spectral aspect of the Cruise Room itself. You are sure to get an earful, and it involves more than being able to offer a toast to Hitler!

So we are finished with the Oxford Hotel, for this trip at least. As you leave the hotel, make sure you bid the hotel staff a warm "Thank you!" as I always do when I have reason to visit this beautiful spot of respite in the bustle of downtown Denver.

Now, step into the sunshine (if it's precipitating, I hope you brought an umbrella so that you may get out of the rain) once more and let us resume our tour. You've got it made! Can you feel yourself smiling yet? Yeah, my stories have that effect on a person.

Street Walking with the Dead in LoDo

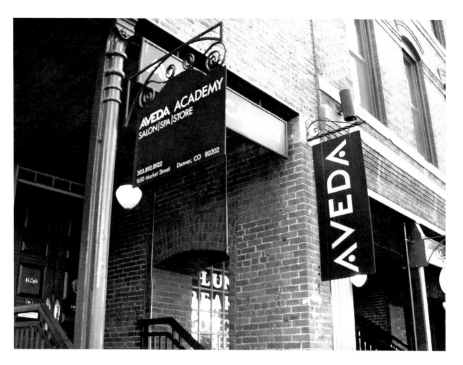

The Aveda Academy, on Market Street, is haunted by a ghost that likes to be around people taking care of each other, a normally friendly presence that can, on occasion, become a little aggressive if you remind her of a sibling.

From the intersection of 17th Street and Wazee, walk along 17th Street away from Union Station, heading southeast, to our next destination. Along the way, you will be passing some of the beautiful buildings of Denver's LoDo district, so make sure you look up as well as around you to admire it all.

When you come to Market Street, cross to the far side and then turn right. Very shortly, you will come to the Aveda Academy, at 1650 Market. No need to go in; you may read about the haunting from the sidewalk.

In the chapter on Capitol Hill, I mentioned the colleague of mine who had the idea to write letters to folks in Denver's old buildings asking for haunted tales. We got one back from the owner of this spa. It is a gentle story, dear reader, to start you out slowly, because there are some far more gruesome things to come as we reach Strangler's Row. Doesn't that sound like a place to locate a vacation home? I imagine the conversation would go something like this:

"Mims, darling, I'm thinking of locating a vacation home near the Carrington-Smythes."

"The Carrington-Smythes of Newport, Rhode Island, darling?"

"No, Newport is simply too passé. No, we are thinking of having our vacation home on Strangler's Row."

"How charming! I will be sure to send the stepchildren there for the holidays."

It could happen!

Anyway, the lady within the Aveda told us of a ghost that haunts her building. Most of the time the ghost is fairly benign, occasionally opening the dryer, moving things around, that sort of thing. From time to time, however, she does get a little more, shall we say, interactive. The ghost does not like to be awakened too rudely in the morning, so woe betide anyone who comes rushing into the building first thing in the morning really, really needing to use the bathroom, throwing down bags, opening doors quickly and loudly or something to that effect. In instances such as those, when the ghost has been awakened from "slumber" too quickly by some boisterous person, the ghost has knocked things over, including heavy salon chairs.

The ghost really shows her opinions at night, however, when the cleaning crew is present. As you may or may not know, after the numerous workers in downtown head home for the night, another army descends on the buildings to clean, remove trash and do everything else that makes the place sparkling once more, kind of like magical elves who help cobblers during the night, except that these workers have social security numbers and the like. The Aveda, like anyplace else, has to be cleaned for the following day, and the ghost has really let the night cleaning crew know what she thinks of these apparent interlopers on her domain.

One woman, who brought her teenage daughter with her, quit because her daughter was physically pushed around by someone who was not there—at least not visibly. Perhaps it had to do with the fact that the girl was in the back of the establishment, where she was not supposed to be (near the cash, computers and other sensitive items). Another lady, upon coming in to clean the Aveda, took off her shoes and placed them by the front door. A short while through her evening of work, she noticed that the shoes had been strewn around the room. She replaced them in their original position. Upon finishing her work and preparing to leave, she found one shoe tossed into a new position and the other one missing. These ladies quit their jobs and never entered the Aveda again. These abrupt departures did prompt the ladies' boss to send a medium to the Aveda to find out what was going on and possibly help this restless spirit pass to the other side.

Street Walking with the Dead in LoDo

The owner of the Aveda acquiesced, but only with the understanding that the medium not force the ghost to leave. By this time, she had gotten rather attached to the special resident of the salon.

When the medium arrived, she was greeted by the ghost.

"Hello, my name is Josephine. You are here to see me!"

The medium went on to relate that Josephine had lived in the early 1900s, apparently unaware that she was no longer living. When the medium asked Josephine about the shoe, the voice of the ghost (whom she could hear but not see) stated that the cleaning woman in question had reminded her of her sister, that she didn't like her sister and she had taken that shoe and was not going to be giving it back. So, somewhere in ectospace, there is a shoe just floating around, awaiting the arrival of a cleaning woman, probably after her own death.

When we read this letter from the owner of the Aveda, we all had a good laugh and came to a private conclusion about Josephine that we would like to share with you here. Unfortunately, our conclusion does involve ungentlemanly language, so if you, intrepid reader, are a lady, we suggest that you sit down at this point, lest the shocking sentiment of what we are about to say cause you to succumb to the vapors and faint dead away.

Are you sitting down? Good!

As we were saying, when we read this letter, we all had a good laugh. We found it amusing that even a ghost can be a bitch.

Whew! If you survived that harsh assault on your sensibilities, you may yet survive what is to come. Let us continue. It is time to see the part of town once known as "the Row." This was one of the many names provided for the area devoted to prostitution, and almost all of this street would have served in that capacity at one time.

Before we do, however, a word of thanks to the Aveda for sharing the information about their mortality-enhanced resident. We hope that you will take some opportunity to enjoy the services of the Aveda at some point in the future. If you do, however, remember this: keep your shoes on.

Now, continue heading up Market Street (away from the 16th Street Mall) with an eye at reaching 19th Street, which is our next destination. On your way, a little bit more about this street's history. It started out with the name McGaa Street. William Larimer, who founded the city of Denver, knew that he had no legal right to make a city where he was doing so, because this entire area belonged, by the Treaty of Fort Laramie of 1851, to the local tribes. He wanted to have a legal claim to the land, even if it was only the veneer of legality. He found a complicit soul in one William McGaa. Mr. McGaa

was, depending on who you ask, either married to one Indian woman with a number of girlfriends on the side or had multiple wives. The Indians did not disapprove of polygamy, and apparently neither did Mr. McGaa. Well, William McGaa "donated" the land for the city of Denver on behalf of his in-laws, and in so doing, he got his name on a street. This street!

Unfortunately for his hopes of a legacy street, he ended up showing himself to be an amazing drunk and not too nice a fellow (as if you could not have imagined that last part), so the city renamed the street Holladay, after Benjamin Holladay, who brought the Overland Stagecoach to Denver instead of one of our rival cities in the area. This stagecoach line would eventually be replaced by the better-known Wells Fargo Wagon.

By the time Mr. Holladay died, however, this place was so hopping with a certain type of commerce that his children were embarrassed to have their name associated with the street. So they petitioned the city to have their name removed. The city graciously complied, and it became known as Market Street because folks were buying and selling things there. Yes, they were buying and selling lots of things on Market Street. As you see, it is not just a pretty name!

After you cross 19th Street, you will have reached Strangler's Row. I have a lot to tell you about this particular block, so I suggest you go to LoDo's Bar and Grill, Denver's premier sports bar, which just happens to stand next to the most famous bordello in Denver's history.

Mattie Silks' House of Mirrors, at 1946 Market, was the most famous "female boardinghouse" to be found, but before I continue, you should get yourself settled. You risk having a fall if you continue to read and walk at the same time, so get to LoDo's (which shares the premises with Mattie's), order the refreshment of your choice (because it really has been a long time since you were in the Cruise Room, now hasn't it?) and continue reading.

Seriously, stop reading until you are settled and your drink is on its way.

I mean it.

All right, welcome back! Now, let us continue searching out the horrors of Strangler's Row. Sip your drink slowly, lest you choke or gag, a bit of self-strangulation.

Denver, like most cities throughout the history of civilization, has a long relationship with the women of the demimonde. Although they were almost universally despised by "good" society, they remained a vibrant and integral part of society overall. Most men, upon reaching Denver, made an immediate visit to Denver's most popular street, and for the city's first major convention, in 1892, the city's promotional machine actually produced a

Street Walking with the Dead in LoDo

The 1900 block of Market Street, filled with buildings both modern and old, was once the location of Denver's most well-appointed bordellos. Unfortunately, it also earned a sad nickname in the autumn of 1894: Strangler's Row.

guide. How very considerate! It was entitled *A Reliable Directory of the Pleasure Resorts of Denver* and bore a red cover. Later on, it simply became known as "the Red Book."

When the men were done with their visit to the pleasure resorts on the Row, however, they did not normally hang around, for polite social interactions lay elsewhere. Most people blamed the women for the sin and corruption of prostitution, accusing these women of "drawing in" decent men.

The truth is that a large segment of society was grateful for the presence of these women. Certainly the crime world liked having them around, for they were big business, not only bringing in the actual fees they charged for their services but also allowing for nearly inexhaustible graft, extortion and the active pursuit of crime. Many cities made up the bulk of their income on fines levied on prostitutes. When finances were low, the police would be sent off to hand out tickets. What a way to balance the budget!

Not everyone tolerated the presence of the brides of the masses, the fallen women, the ladies of ill repute, the soiled doves, the ladies of the tenderloin (that's a real charmer) with such equanimity, however. In 1888, a number of prostitutes died in a most gruesome manner at the hands of a man who

Above: LoDo's Bar and Grill, located at 1946 Market Street, is the location for libations as one reads of the exploits of Jack the Strangler and the ladies who once worked next door in Denver's finest house of ill repute.

Left: Mattie's House of Mirrors still stands today, though no longer serving its original purpose. Part of LoDo's Bar and Grill, the interior still holds traces of the refinement that could once be found within its mirrored walls.

would bear the name Jack the Ripper. This story was sensational and sold newspapers all over the world, including Denver. Eventually, Denver would get its own turn at vicarious enjoyment of ghastly death, and it would take place right here on this block of Market.

Prostitution has been somewhat romanticized in many movies and television shows of the modern day. Think of the movie *Pretty Woman* or the madam Belle Watling with the heart of gold, who turns out to be better behaved than Scarlett O'Hara, in *Gone with the Wind*. From television shows like *Firefly* to the Broadway stage in *The Best Little Whorehouse in Texas*, this occupation has definitely gone through some polishing since the days when it was rampant in every city in the nation. The truth, however, is that women did not want to become prostitutes. In all of my readings, all of my research, never have I found an account of a woman who got into the business because "I simply couldn't get enough!" No, at a time when the social stigma ran very strongly and the religious community held absolute sway of daily life, women who got into this line of work did so because of economic duress. There were simply not that many choices for women. A young woman lacking looks and money, one widowed early in life or orphaned before she had been able to learn a skill might all have found the prospects quite daunting. The choices included marrying, the one most frequently chosen, being an old maid or taking a job, and very few jobs paid enough to sustain a man, much less a woman, in a time when unequal pay was the norm and not the unspoken exception.

The women on the Row were outsiders, scorned by most everyone, and the tribulations of their lives did not make the society papers. They lived large, and then, as their looks faded, they began their long tumble down the Row. Where you are sitting now, the 1900 block of Market Street, held the finest of the seraglios, and the farther away you got from it, the cheaper things became. Even women who started out their time in the greatest pulchritude could not depend on staying so. The work could make demands on them that would cost them much of their youth and comeliness. Additionally, there was rampant drug abuse among the women and physical abuse from the men who came to see them. Just as they were outside the law in their profession, these women were often outside the law in pursuing redress when they were roughed up. A woman who lost teeth or had a broken nose that set crooked would find herself no longer welcomed in the finest houses on this aptly named street.

So, society tended to ignore these women as individuals, unless something really sensational happened to them. In the autumn of 1894, several such

events happened, and it set the typesetters of the city's papers clicking and the tongues of its residents wagging. In honor of Jack the Ripper, working his evil deeds just six years before, Denver's fiend would be dubbed Jack the Strangler.

"Lena Tapper Meets a Terrible Fate. Strangled in Her Bed. A Twisted Dress Waist Formed the Deadly Noose. The Work of a Fiendish Heart." These were the headlines on September 4, 1894, in the *Rocky Mountain News*. The story continued: "At 1911 Market Street yesterday morning was committed a frightful crime; Lena Tapper, a woman of ill fame, being heartlessly strangled to death upon her bed. Evidence that she struggled terribly against the strangler."

The newspaper considerately provided a drawing of the woman and went on to describe the floor plan for the small apartment where the woman had conducted her work. The location of her murder, as the police said, was "the ideal place for a dark and murderous deed."

The paper also obligingly offered what the woman had been wearing and the state of the corpse once found. Suspicion fell on a number of men, including her lover, but no immediate progress was made in solving the case. Further livid details emerged about the state of Lena's body. Her face and her bare bosom were covered with bruises, leading some to guess that her killer had underestimated her strength.

> *As was shown by the deep cuts his nails had made in the flesh of her throat, he had to hold her windpipe tightly to prevent her from crying out, and so determined had been her struggle that he had to supplement the work the fingers of his right hand were doing with the blows from his left fist. When he at last had her unconscious, he took an old chemise, twisted it into a rope, and tied it about her throat. Then he was able to watch at his ease the ghastly performance between strangulation and death.*

Toward the end of October, the papers blazed up with death once more: "Suspect Strangling. Another Woman Found Dead in Bed on the Row. Marie Contassolt Discovered Dead by Her Lover. Heart Disease, Apoplexy and Murder Variously Given as the Cause. The Police Cling to the Murder Theory and Have Placed Three Men under Arrest." The article relates how the woman's paramour found her stretched out in her room: "The body was upon its face, the right arm below her forehead. She wore only a short, knitted chemise. All her other clothes were lying upon the floor near the bed."

Street Walking with the Dead in LoDo

Nearly naked corpses really help to sell papers, you know, so it is best not to leave that kind of detail out of your article. No pictures were available. Apparently no one thought to go get their Instamatics! Oh yeah, the year was 1894. Well, since cameras were fairly uncommon, certainly not as ubiquitous as today (think of cellphones!), the newspaper had to provide its avid readers with enough details to form the gaudy images in their own imaginations. As you might expect, the newspaper earnestly fulfilled this public service. Just imagine the vicarious chills experienced by each person reading the accounts of the deadly deeds over his or her breakfast.

When the woman's lover called her but received no answer, he shook her. She did not move. He grabbed her shoulder and turned her partially over, then seeing that "the woman's face was black, the discoloration extending to the neck, and her teeth were embedded in her tongue, which partly protruded from her mouth. Her arms were also discolored. There were blood marks on the pillow; blood had gushed from her mouth."

Though the police concluded that there was no evidence of a struggle, Marie being a very slight creature, the fact that Marie's considerable amount of money was missing and that there was a length of rope "buried in the swollen flesh" of her neck led the police to believe that such commonplace suggestions as heart disease and apoplexy were simply not the correct assertion. Clearly, this woman had been strangled, a belief that would be solidified in the newspapers and police reports subsequent to the death.

By this time, the women on the Row were starting to get concerned. Was a grim reaper walking among them, using not a scythe but the merciless strength of hands or coil of cloth? It certainly seemed to be so.

With the third strangulation, in November 1894, the headlines grew even larger on the page, literally, fairly shouting out the terrible, repellant, hysteria-inducing, paper-selling news:

> *STRANGLER. Suspicion That It Is a Denver Man Affected with Mania. Three Women Are Garrotted Within Ten Weeks. Stories of Mysterious Tragedies Never Equaled Outside Great Crime Centers. No Single Clue by the Strangler After Any of the Horrible Murders. In the First Strangling Was There Even Evidence of a Struggle. Women on the Row Are Terrified, Not Knowing Who May Be Next.*

The paper went on to say that the same remorseless hands had strangled three women on the same block, without a single clue offered to the police.

Though Lena had been of German descent and Marie of French, the third victim was the most exotic of them all. Her name is spelled Kiku in most places and Kika in others. "Then was found a Japanese girl murdered. Kiku Oyama was a frail little thing, weighting ninety pounds at most. As the body lay in the morgue yesterday the limbs looked frail enough to crush between the palms."

One has to wonder something about the author of the newspaper article here, I must interject. Is this something one frequently envisions, especially when faced with a strangled girl on a mortician's table? I'm just asking.

Moving on. "She too (like Lena and Marie) had made a fortune on Market Street. Being the first woman of her race to appear on the Row, money fairly poured in upon her. She was a rarity, and visitors flocked to her house."

Though other Japanese girls had arrived on Market Street since Kiku's arrival, the newspaper boldly declared: "Kiku remained the queen of them all. Even the past two weeks she had been boasting of how much money she was making. What became of Kiku's money has so far not developed. It is certain, however, that no Frenchman and no French organization had anything to do with it."

Well, that's a relief. Mark the French off your list of suspects, gentlemen! It is safe to eat pâté again!

The article goes on to relate how a man from Kiku's own country who passed as her husband (sounds to me like he is being accused of being her pimp) came to see if all was well with her. He found all the doors open and Kiku on the bed, face toward the wall. Then, in an age before politically correct terms were de rigueur in the newspaper, the article continues: "The Jap spoke to her, touched her, turned her over. Her face was discolored and distorted. A twisted towel was about her neck."

Three murders in three months had the police scrambling and the people agog. What would happen next?

It would get even stranger, that is what would happen. "Told a Weird Tale. A Clairvoyant Bobs Up in the Strangling Case. Even Some of the Police Were Rather Impressed. She Makes the Big Hit of the Day and Seems to Be About as Near Locating the Strangler as Anybody Else—On the Row the Alarm Among the Women Is Unabated."

Before I became more familiar with the peculiarities of history, especially history in the Victorian era (and trust me, there were lots of peculiarities in this hyper-repressed, overdressed time), I just assumed that a time when everyone was religious and regularly attended religious services would be a time when things that smacked more of the pagan, such as Ouija boards,

Street Walking with the Dead in LoDo

tarot cards and phrenologists, would not be tolerated. Nope! Read on, noble ghost hunter, read on!

The newspaper reported that there were some "peculiar proceedings" among the detectives who were working to "ferret out" the identity of the strangler and that the police would have a good chance of capturing him soon. "The aid of an occult power is being invoked with the object of identifying and locating the guilty party, and certain persons were astounded by revelations made!" Yep, you read that right. The police were openly using the services of the occult.

> *The greatest consternation prevailed upon the Row last night as the result of a visit paid to 1957 Market Street* [the location of Kiku's death] *during the afternoon by a couple of ladies. One of the ladies was a clairvoyant and she made some revelations that cast a deadly fear into the hearts of the women living in the neighborhood.*

The story goes like this. A pair of ladies approached a member of the constabulary, Officer Boykin. They asked Boykin to take them into the building, so he got the key and led them into Kiku's bedroom, a good number of detectives following.

I don't watch crime shows or anything like that, but one has to wonder how a supposed clairvoyant no one even knew (and a herd of detectives) might have played havoc with the crime scene. The woman declined to give her name, saying she did not want to draw any notoriety to herself. In the old days, it seems practically anyone could visit the location of a murder; it's a wonder they didn't sell tickets. Imagine how these tickets might have sold had they left the bloody sheets on the bed!

I suppose the deciding factor was that the clairvoyant was "quite pretty." Further, "she wore a veil, which she drew back upon entering the house, displaying clear cut and regular features." Well, clearly she is the sort who we may trust. As everyone knows, people who are attractive are always good, kind and trustworthy, and people who are ugly are always shifty, reprehensible and conniving. Huzzah for life being distinctive black and white!

Anyway, the medium stood by Kiku's bed, closed her eyes and placed a hand on her forehead (the medium's forehead, not Kiku's). Then, just so you know what's coming, a sub-headline is offered: "Witnessing the Crime." "She remained in this position for some time after enjoining absolute silence on the part of the others in the room. About five minutes elapsed before the clairvoyant uttered a word. From the statements that she

then uttered, the affair in its horrible details seemed to pass as a panorama before her eyes."

She described the killer at length, clothing and facial hair, saying he had "bright, gleaming eyes." His stealthy approach, spellbinding the awestruck listeners, was followed by sudden movement. "Before his victim could escape or scream, he grasped her neck in a terrible grip, with his knee in her back."

After dropping Kiku's lifeless corpse onto the bed, he then moved to her dresser and began milling around among her belongings. Eventually, he picked up a small bottle and raced from the back of the building into the alley and out into the night.

This information was lent some credence by the law because it matched some of the facts. According to the paper, there had been a witness, someone who saw a man fleeing from the alley. As people were constantly going and coming (so to speak) in this neighborhood, the man did not necessarily think anything about it. Also, before the ubiquitous streetlights of today, things would have been much darker. The eyewitness saw someone leave the alley between Market and Blake Streets, throwing something down as he left. The descriptions given by the man matched those offered by the clairvoyant. Further, when the police found what had been thrown down, the pieces of the shattered bottle were identified by Kiku's colleagues as being hers.

Women on the Row were convinced that the strangler was not yet finished, that he would continue to increase his tally of victims mercilessly, and the fear among them reached fevered proportions. These terrors were exacerbated by the fact that Lena's ghost was reported to be seen several times, haunting the buildings near the site of her death.

No further strangulations took place in the area, and it seemed that Jack the Strangler, whoever he was, had disappeared into the night for good.

Now, at this point in the tour, I used to suggest that because of the notoriety in the paper, and because the clairvoyant had been able to give details of his appearance, the man must have mended his ways and ceased his murderous rampage among the sisters in infamy in Denver. On one of my tours, however, I had a lady disagree with me. Her protest went something like this:

> *I am a criminal profiler with the police force in such and such a place, and I guarantee to you that this fellow did not stop killing. Sociopaths like this do not stop unless they are caught or they are killed. All he did, you may be virtually certain of it, is change the location of his crimes. If you look through the databases of other cities nearby, maybe even other states, I am sure you will find something just like the murders here on Market Street.*

Street Walking with the Dead in LoDo

So I asked a colleague of mine who is good at research to do just that. He found an article from the *Mercury Newspaper* in Hobart, Tasmania (of all places!), and it told a very distressing tale. It was dated May 25, 1896:

> As he is a wanderer, instead of choosing the same city and the same district for the gratification of his perverted desire, his work has not attracted as much attention as the work of Jack the Ripper. Nor has he the same desire for notoriety which caused the Ripper to write anonymous letters about himself. Still, those who have made a study of these matters are of the opinion that the long series of crimes done in various cities of the United States are in all probability the work of the same brain.

The first crime that followed the Strangler's mode occurred in 1894 in New York. At the time of the article being written, in 1896, his most recent murder had taken place in San Francisco, "according to the rather imperfect police record." The article offers guesses as to the lapses between murder sprees.

> It may be that, like many of these monsters, his mania for taking a woman's life only comes at intervals. It may be that he has been committing crimes straight along, but the deaths have been attributed to other causes, or have been in such out-of-the-way places that no one ever thought of connecting him with them. Again, it may be that he is a member of the general criminal class, and spends part of his time in prison for small offences. Or, as many believe, and as we believed of Jack the Ripper, he may be a sailor, and absence on the sea may explain [the gaps].

His victims were always of the lowest class and moved about "almost completely disconnected from the rest of the human race."

A neighbor of the first prostitute killed, in New York, described a pleasant-looking, clean-shaven man leaving the apartment where, later, the body would be found. As he passed her, he was smiling, but there was something horrible in the smile.

The next victim, in Buffalo, New York, was "a thoroughly depraved outcast." In Cincinnati, "a woman of the most dissipated classes" would die, to be followed by the three unfortunate souls in Denver. A month passed between his foul deed in Ohio and the arrival of his special brand of terror in the Mile High City, for which "there could not possibly be a better place

for the sort of work that pleases his perverted brain." "In Denver there was then a part of Market Street where scores of women lived, each in a separate shanty. The walls between these shanties were thin, so thin that by talking loudly the women communicated one with another without the trouble of going through doors."

After a lapse, the Strangler showed up in San Francisco, killing two women using the same general method before reaching a new level of depravity, ending one poor soul's life by simply shoving rags down her throat until she suffocated.

The article in the Hobart newspaper pointed out that Jack the Strangler never left any clues and there was no indication he would be caught anytime soon. "Like the Ripper, his career is pursued at his own pleasure, and does not depend upon the police at all. As he attacks only friendless outcasts, whose movements, from the very necessities of their mode of life, are sly and secret, he need never fear discovery so long as his first grip on his victim's throat is sure."

Learning all that almost makes me wish I hadn't asked my colleague to go looking for that information after all. What a sad tale! Denver's part in this tragic infamy will indelibly remain on Market Street, even though the ghosts created by Jack the Strangler's hands have now been silenced by time just as he silenced the living voices of the women who preceded them.

So, at this point in the tour, you may be thinking that being a prostitute on the Row was dangerous as well as socially stigmatized, while the men had it easy and safe. Lest any of my male readers feel too smug about their own situation in the olden days, I need to let you know that the men, too, were stepping into a dangerous realm each time they walked through those doors. To illustrate this, we bring up the case of Mr. John Fitzgerald.

Mr. Fitzgerald, a barber from Leadville, came to Denver in the spring of 1884 with a large parcel of money in order to do some shopping for barber supplies. This was a sensible idea, since Denver was the center of the state and had a larger selection of materials from which to draw. Another sensible idea, as any man of the time would have agreed, was to fully explore the entertainment options that the Queen City of the Plains had to offer. After all, Mr. Fitzgerald was going to be away from his wife and her feminine charms for days, a truly dreadful and cruel punishment, as any man knows. So, while in Denver, he decided to visit the female boardinghouse of a woman named Bell Warden. Within its confines, he booked the company of a young woman named Mattie Lemmons.

Then he disappeared.

Street Walking with the Dead in LoDo

Mr. Fitzgerald's story did not end there, however. The newspaper obligingly shared the juicy details of what came next. "A Barber's Body. Found in the Sands of Cherry Creek Yesterday by a Bevy of Playing Children. After It Had Been Run Over for Two Weeks by Them, and Supposed to be a Bag of Sand. A Deep Mystery Surrounding the Matter—Was He Murdered or Did He Commit Suicide?"

Then, using its customary blend of over-the-top description and really amazing understatement, the newspaper continued to relate the tragedy of Mr. Fitzgerald, saying: "A discovery of a somewhat startling character was made." The children had found the hand of a person extending a short distance above the surface of the water. Yes, I could see how that would be somewhat startling. By the time the coroner and the reporters arrived, one thousand people were eagerly looking on from around the edge of the creek. It seems the children had spread the word of the appalling discovery, to the great consternation and delight of all. What were they looking at, you ask? As the print of the newspaper goes along, describing all, it draws out these words in a special column of larger print: THE WHITE HAND. Great stuff.

Though the body was badly decomposed, at least the clothing was good and the underclothes were of a fine character. Remember, folks, what your parents always told you: it's always important to wear clean underwear in case you are in a car accident or found decomposing in a creek. Don't forget that!

His pockets held a number of items that helped identify him, including a claim ticket for a locker at Union Station. The locker's contents solidified the deal, holding a piece of luggage labeled with the man's name. With a name, the investigating forces were able to begin their search for the circumstances of his death. When contacted, Mr. Fitzgerald's wife told investigators that he had left for Denver with a very large amount of money.

We know a number of things about this story. We know many of the events leading up to it, and we certainly know how it ends, but there are no real records of what happened between these two chapters, the bookends, if you will, of Mr. Fitzgerald's story. Based on many things, we are forced to surmise some of them, so let me give it a go.

Mr. Fitzgerald was going to be gone from his wife's feminine comforting, a truly egregious condition for any man. He was a man in need of solace. Mr. Fitzgerald, upon being ushered into the chamber where his little slice of delightful solace would be administered, began the necessary act of disrobing. This is where he made his tragic mistake, the mistake that would cost him much more than the loss of his barbering profession. As he

undressed, the young lady with him noticed something in his pants. There, with a gasp that might well have been audible despite her attempts to stifle it, she glimpsed his enormous, his gigantic, his prodigious wad…of money. Yes, as I have already mentioned, he was carrying a veritable mother lode of cash with which to do his shopping, and what a mother lode it was! His massive tube of bills no doubt made the young lady's eyes goggle. (It might be hard for the temperate readers of the modern day to comprehend, but in the 1800s, people actually found large amounts of money compelling and enviable. Aren't you glad we live in a more enlightened time?)

How Mattie Lemmons must have cooed! How she must have praised the enormous package filling out his pants. One may only imagine how Mr. Fitzgerald puffed up in his pride at sporting such an endowment. How his spirits must have risen, floating upward and filling out like a hot air balloon! Ah, one may only imagine. Ah, the allure of a big lode of cash! Alas, Mr. Fitzgerald was going to lose more than his lode.

What happened next? Well…we'll skip that segment of the story. If you don't know what happened next, ask your parents to give you a little lesson on such things, as you won't find them discussed here. This is a quality literary work, not filled with things lewd and libidinous. Suffice it to say, in the afterglow that followed, Mr. Fitzgerald found himself getting dressed once more, reveling in what had taken place. Who could blame him for thinking that the young lady, nubile and lovely beside him, could not be thinking anything other than similar thoughts of bliss? Who could blame him for missing the tiny gesture of her hand? Basking in remembered sensation, he did not notice her motion, summoning a colleague, a brute and burly man, who would help her accomplish her nefarious work. Still incandescent from this comforting visit, Mr. Fitzgerald's throat was slit.

Talk about a downer!

Target deceased, cash acquired, there was now nothing left but to dispose of the evidence. Believe it or not, that is where things start to get *really* interesting.

Bell Warden's boyfriend was also a hack driver. For those of you who might not know, a hack was a horse-drawn conveyance that served the role of taxi in the olden days, before cars became ubiquitous. They placed Mr. Fitzgerald's body in a sack, and the hack driver unceremoniously dumped everything in the waters of Cherry Creek. No doubt everyone hoped that the waters would wash the body away, absolving them of the deeds only recently taken place. At the time, Cherry Creek, far from being the pleasant waterway of today, was the city's primary dump and frequently its toilet as well.

Street Walking with the Dead in LoDo

As you know, that is not quite how it worked out for them. Mr. Fitzgerald's body remained relatively stationary, rotting in accordance with the natural order of things and being tenderized by the joyous footsteps of playing children. All these events culminated in the discovery of that pale hand, which led the police to investigate. "Deviating somewhat from the usual mode of procedure, the police and detectives of Denver have been doing some remarkably accurate and good work in their endeavors to ferret out the cause that led to the death of John G. Fitzgerald." Seems the police had something less than a stellar reputation in those days.

Bloody bedclothes were discovered in the basement of Bell Warden's place. When confronting the residents of the bordello, there were multiple confessions. The hack driver readily admitted his part in the crime, since he had been haunted for the ensuing weeks by a desperate voice from within his carriage. During those weeks after making a rather unusual deposit along the banks of Cherry Creek, the words "Stop! Stop! Stop!" had frequently sounded from within the confines of the carriage, even when the driver knew no one was there. At one point, he heard the voice and a frantic knocking from within when he did have a passenger. The driver stopped suddenly and opened the door, the passenger leaping out and racing away in fear of his unwanted fellow passenger: the hack driver saw a rotted corpse reclining against the seats. Charley Smith, the hack driver, "squealed," according to the newspaper, in order to relieve a "heavy burden." He was afraid the ghost was going to get him, for on a number of occasions, he reported, the horse had raced him and the carriage to the spot where the body had been found, despite his efforts at stopping the horse's movements. Charley knew the ghost was still around.

Mattie herself was besieged by wrenching visions, seeing everything she touched covered in blood, no matter how many times she tried to wash her hands clean. Mr. Fitzgerald's blood would not be expunged by mere soap and water; his ghost was going to make certain of that.

With ample evidence that the parties involved were guilty, Bell Warden, whose profession was listed as "hairdresser," and Mattie Lemmons, bearing the profession "housekeeper," were sentenced along with their male co-conspirators. Both ladies cried during their sentencing, which served to soften the judge's anger. The ladies' sentences were reduced, but they still went to prison. The ghost of Mr. Fitzgerald was not appeased.

Subsequent to his death, and with the abandonment of the business that Bell Warden had run, there were reports of strange sounds coming from the interior of the building and areas nearby. Blood would appear

on the sidewalk, to the accompaniment of the sound of a heavy burden being dragged, like a body. Folks would hear a frantic "Stop! Stop! Stop!" Even after the building was torn down, the despairing voice continued its plea for many years. For Mr. Fitzgerald, however, the pleas were too little and too late. Today, the spot is a parking lot, and Mr. Fitzgerald's voice has been silenced by time, but the lesson he learned remains with us as powerful echoes. The Row, as it was known, was a place of danger for everyone who took part in its way of life. If you ever go back in time and care to take a visit, tread cautiously.

So, are you comfortable? Are you enjoying your drink here at LoDo's? I hope so, because now it's time to order a snack and resettle yourself. I could hardly bring you here without offering you some tidbits relating to the modern day! That's right, the building you are in is quite haunted. Have you felt its presence as you have been reading? Perhaps you've been so focused on the text that you have not felt anything of the sort. Perhaps you've been saying something to yourself along the lines of: "Self, this is really one of the most amazing books I have ever read. Whoever wrote this must be astoundingly good looking, intelligent and humble." Well, setting those truths aside for the moment, refocus your attention on the room around you and open your senses to what awaits you here, for it is definitely not of this world.

As you know, LoDo's owns and is attached to the building that was the most famous bordello in Denver's history, the famous House of Mirrors. Today, the two sections of the building are quite open in their flow from one to the other. You may even see the stairs leading upward—the stairs that would have taken yesterday's lovers to the revelries of their choice.

Things were not always like this, however, both in the calm efficiency of the staff and in the actual construction of the building. The House of Mirrors was built by one of Denver's earliest queens of the demimonde, a fiery-tempered lady named Jennie Rogers. Rumors and urban legends abound about how Jennie got the money to build her palatial house of ill repute, including the legend that she blackmailed well-to-do men in society in order to get the funds. Whether true or false, the House of Mirrors was truly sumptuous, sporting everything of the finest. Mirrors, an expensive feature, no doubt lent the appearance that the place was much larger than it actually was. In the lower level of the building, the women would socialize with each man who came in, getting him drinks, chatting about the news of the day, finding every joke the man said simply hysterically funny and helping him forget about the cares of his life, which might include a "shrewish wife" at home, a woman who continually harped on him about money, the kids, his

job prospects and much more. Upstairs, when the man was ready, he would find respite of another sort. The men who entered the House of Mirrors had to be cleanly shaven, well dressed and freshly groomed. No drunkards entered here, and they could count on the fact that they would be offered some of the finest choices Denver's tenderloin had to offer. For this honor, they paid a high price. Many found the added expense well worth it.

Eventually, the business was bought by Mattie Silks, who would bring it to its fullest glory. Mattie was a shrewd businesswoman, whatever one might say to impugn her taste in men (but that's another story), and had the House of Mirrors run as a well-oiled (should I say well-lubricated?) machine. The sporting life was finally run out of Market Street during the wave of progressive ideals that suffused the 1910s, a decade that would bring in glorious triumphs such as universal suffrage as well as poorly considered travesties such as Prohibition. With Mattie and her girls gone, the building became a Buddhist temple. Yes, you heard that right, a Buddhist temple. The city's current downtown choice for that religion, the Tri-State Buddhist Temple in Sakura Square, had its immediate predecessor in what was once a bordello. Clearly, the Buddhists were not worried about the affairs of the flesh that had happened within the building. Eventually, the temple departed and made way for a number of businesses, including what it was when I entered the building to give my first tour: Mattie's Red Light Lounge. This was a rental party space, owned and run by LoDo's and built in the guise of the bordello it had once been, though with a large open space on the second level ideal for groups, rather than numerous smaller rooms ideal for duos. At that time, the entrance to the building looked much the same, but the connection between the two buildings was restricted to a set of beautiful French doors located underneath the ascending stairs. The open wall where the stairs descend today was closed at that time. Mattie's Red Light Lounge saw bachelorette parties, office meetings and numerous other events, and when we were doing our tours, we would enter through LoDo's, after asking permission to do so, of course.

We spoke with members of the staff and heard some stories both frightening and verging on comical. Let's start with the comical, shall we? We've already had a ghost that likes to watch women use the bathroom. Well, here in LoDo's and the attached House of Mirrors, we were told that there is a ghost of a man who apparently did not get enough in life and so is still trying to get some in death. Two female members of the staff that we spoke to reported being "inappropriately touched" by someone who was not there. If you don't know what that means, we encourage you (again) to

call your parents and ask for a quick primer in these things. Remember, this place was a bordello or, in another euphemism of the day, a "men's clothier." I always thought it should be a "men's declothier," but who am I to argue with history?

So for my female readers who are not being adequately wooed at home, or for those who would simply like to experience a taste of the other side, this would be the place for you. Remember to show off your alluring ankles! Who knows? You might get lucky. Just remember to bring along a towel or something similar, in case the ghost leaves behind some ectoplasm.

On one tour, when one of my colleagues was asking permission to enter Mattie's, she very kindly offered the man on duty, a big, muscular and tall bouncer type of fellow, the chance to come along and listen to her regale the tour group with the stories of the ghosts in Mattie's. "No," he replied, "I don't need to hear about it. I've already experienced it." Pressed to share the details, he related what had happened to him.

He stated that he had worked there for quite a while and was closing the place down one night, as he had done many times before, a process that entailed cleaning, turning off lights and just generally getting the place ready for the next day's guests. They'd had an event in Mattie's, and after making sure that all was secure on that side of the building, he came through the French doors (these no longer exist, remember) and closed them behind him. The stained glass of the doors showed only darkness on the other side, Mattie's Red Light Lounge. He inserted the key in the lock and sealed the room behind him, ready to move on to his other duties on the LoDo's side of things. Behind him, he heard the door rattle.

> *I didn't think anything about it, at first. I thought maybe I had locked someone in who I had missed in the bathroom or something, or some homeless person had been hiding somewhere to get out of the cold outside. So I unlocked the door and opened it once more. I turned on the lights, but even before that, I could see that no one was there. I wondered if someone was playing a joke on me. I looked around but found no one. Somewhat disgruntled, I closed the door again and locked it. Suddenly, the doors began to shake violently, as if someone on the other side had taken hold of the doors and was yanking them back and forth. It was all I could do to make myself do it, but I opened those doors one more time. Again, no one was there.*

My colleague related how the man's face was transfixed by his memory of the fear of the event. Though a big man, he was clearly as rattled by the

Street Walking with the Dead in LoDo

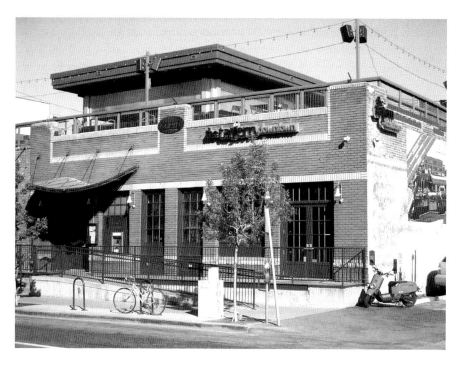

The Tavern, formerly known as the Soiled Dove, is not normally haunted, but on one night, when the future of one young woman really depended on it, a ghost found a way to communicate a vital message.

experience as the doors had been. Being afraid of ghosts is not determined by size, clearly, so if you're going to flirt with all the ghosts in Mattie's, no need to do a bunch of push-ups beforehand.

Now our story veers outside of Mattie Silks' House of Mirrors and returns to another building on the block, though you are welcome to sit here and read the story. Once you have gotten to the appropriate point in the book, I will lead you to the spot outside where you need to be. So read on!

We did not only get a letter about the ghost at the Aveda Academy when we did our letter-writing campaign. We also got one back from an employee of what was, at the time, the Soiled Dove, a restaurant and bar on Market Street, but the other side of the block. It is the last building before the corner parking lot, across from El Chapultepec.

Although it is, at the time of this writing, called the Tavern, when we got the letter back it had the name that harkened back to the bordello days of old. The letter was written by one of the female employees there relating that not all ghosts are meant to be scary. In fact, it's entirely

possible that this ghost saved the young woman from something no one would care to imagine.

Two employees of the Soiled Dove were closing down one night. One of them had parked her car in the alley so she would not have to walk as far once her shift was done. They chatted amicably as they went about their normal routine of cleaning, putting up chairs, turning off lights, all that sort of thing. It was a night like many before, for they had both been employees there for quite a while, and closing up for the night was a known and easy part of their day of work.

Eventually, with the place clean and ready for the next day, the two women bid their goodnights. One of the ladies would be going out the back door to her awaiting car, and the other would be going out the front door to walk a block or so to her car. Each would lock the door behind her, securing the bar for the night. From there, they would head home and hit the hay. It was as normal as could possibly be.

"Goodnight!"

"Yeah, goodnight! See you tomorrow."

In the darkness of the bar, quiet and unmoving, the lights around the stage area suddenly flashed: red! red! red! Both women knew they had turned all the lights off. They could plainly see that they had turned all the lights off. In the semidarkness, their shadowy faces partially illuminated by the streetlights outside, they looked at each other in some degree of disquiet. What did this mean? Was there an electrical issue? Had they forgotten to turn off one of the lights?

One of the women moved to the area with the lights for the stage. The stage was not large but was big enough for the bands that frequently played within the bar, providing live music for the bar's patrons. Around its edge were lights that could illuminate in multiple colors, a miniature light show to visually jazz up the performance of the band. The lights were off. She turned them on and off again a few times, experimentally, and found that nothing seemed amiss. Returning to her colleague, they shrugged and murmured, without any genuine worry, about how strange it was, that sort of thing.

"Well, goodnight."

"You too. Sleep well."

Then, from the stillness of the bar, one woman preparing to walk across the darkened room and out the back door to her car, the other with her hand upon the front doorknob, the lights repeated their colorful entreaty: red! red! red!

At this point, a tingle of dread tickled its way along the base of the skull of the woman who would be entering the alley and the awaiting night.

Street Walking with the Dead in LoDo

Coldness filled her stomach, and she had a strong sense of apprehension. Someone was trying to tell her something, and these flashing lights were not just colorful. She had the conviction that they were flashing a message: careful! careful! careful!

She turned to her colleague. In the meager illumination of the room, she was not certain if her friend had grown pale or if it was merely the queer cast of the streetlights, but she had the feeling that the woman shared her apprehension. Both stood frozen for several seconds, the one woman's hand stopped in its motion on the front door. The lights did not flash again, but the feelings persisted. Something was really wrong. They could both feel it.

So the woman who was going to be going out into the alley, suddenly completely unnerved by the experience, asked her colleague if she could walk with her to the colleague's car and be driven to her own car in the alleyway. Softly, the woman answered yes, and they went out the front door, locking it behind them. The door clicked with finality, and they walked without any conversation.

Once safely ensconced within the car, they drove along 20th Street and then turned into the alley between Market and Blake Streets, approaching from the northeast. The night was dark, and as the car turned into the alley, the headlights first shone on the woman's waiting vehicle. Then, as the turn continued its arc to illuminate the full extent of the alley before them, they saw something that chilled them both to their very cores.

The rear exit from the Soiled Dove is somewhat recessed, so one coming out of that exit would do so, close the door behind and enter the alley before any realization might take place that something in the alley might be awry.

In this case, the darkened alleyway was not empty of life. Two men

The exit from the Tavern into the alley behind it looks commonplace in this daytime photograph. Once, in the darkness of early morning, however, this door was almost the point of no return from a deadly encounter.

stood pressed against the walls on either side of the door. Their stances were not ones of someone waiting to spring out and yell something like "Happy birthday" or the like. Indeed, as the headlights from the car entering the alley strafed their lurking forms, both men went racing down the alley in the opposite direction, feet pounding the pavement in guilty retreat from the eyes of the women in the car.

According to the women, the building has never shown any signs of being haunted before or since, and I have actually gone in and spoken with members of the staff subsequent to learning about the events of that night. No other phantasms have shown themselves within its walls. That night, however, when it really mattered for the young woman with her car in the alley to be told that something was truly wrong, a ghost got enough power together to let her know the truth. We may never know what the two men intended, but knowing the sad state of the world from time to time, one may imagine what they might have had brewing in the prurient recesses of their minds.

Now it is time for you to leave the marvelous and welcoming LoDo's (that's right, it's time to leave, so drink up, eat up, pay your tab and let's go!) so you may have a pass by the Tavern, the building that used to be the Soiled Dove. If you wish, you may make a quick jaunt over to Scruffy Murphy's, at 2030 Larimer.

It's a little off our tour route, but I recently learned that it, too, is haunted. The downstairs is used by the living and upstairs is used by the dead. Have a visit and a drink, and ask for details. I won't lead you over there today, however, since it's slightly off our tour route. Anyway, I've been giving you so much satisfaction today, I thought it would be nice to just tease you a little bit. You'll have to find the climax of this particular story on your own!

Anyway, from LoDo's, head across Market Street and around the Tavern, walking behind the building through the parking lot that now occupies the spot to the bar's northeast. Go into the alley. Sure, the smells might be a little less than savory, and who would normally want to do a tour in an alley, but this spot has two claims on the fame of all things haunted, and we need to touch on both of them here. First, notice the rear exit from the Soiled Dove (today's Tavern) on your left. Notice how it is recessed and how readily people intending to be ugly could hide themselves to either side. Now, when I am giving this tour, I usually press myself up against the wall to illustrate, which only works to a minor degree because I always have a backpack on, and that prevents me from getting truly squished up against the wall. But

Street Walking with the Dead in LoDo

Scruffy Murphy's Irish Pub, in Denver's Ballpark neighborhood, offers all the best the Irish have to offer. Listen closely as you enjoy your libations. Though the upstairs is closed off to the public and staff members alike, movement is still heard quite frequently. Perhaps it's a wake lasting all eternity!

imagine two large men, without backpacks, on either side of the doorway in a darkened alley in the wee hours of the night. One's imagination need not be too vivid to picture it quite clearly. If you look toward the southwest, you see the direction the men fled as the lights from the car illuminated their lurking forms.

You are also looking toward the direction where Kiku drew her final breath. If you return to the exit of the alley, there on 20th Street, you will be right about where the witness was when he saw a man come running out of the alley and into the anonymity of the neighborhood on the night that Kiku was murdered. So this alley has had its share of moments unhappy and despairing.

Upon returning to 20th Street once more, head northwest, which is the same direction as the baseball stadium, and away from Market Street, also known as Strangler's Row. It's been a long time since those awful events took place, so now it's time to put them behind us literally as well as figuratively and move on to a different subject: racism.

Yes, the ugliness that is racism has left a number of egregious marks on Denver. As you walk along 20th to Blake and turn left, you will be seeing one of them. You probably won't realize that you are seeing it because this is a legacy of racism left not by what is here today but by what is *not* here today. This general area, especially the nearby alleys (and you were just in an alley, lucky you!), was once home to another set of folks disliked by "good society" in the civilized West, the ethnic group unloved more than any other: the Chinese. Most folks don't remember how maligned the Chinese were, feared as the "Yellow Horde," with customs that were far beyond the somewhat less different customs of the Italians, Irish, Catholics, Jews and other groups that came pouring into the United States from the east (though these groups were certainly disliked too). Though many of the Chinese had come in order to work on the trains and in laundries, their assimilation was not encouraged.

Here, in the area known as Hop Alley, was Denver's Chinatown. The name derives from the numerous opium dens that the Chinese ran, providing access to the fruit of the poppy not so much for themselves as for a very demanding American public. Thus, Hop Alley was not only depraved in most people's eyes because it was Chinese; it was further so because it provided yet another substance for the destruction of one's life.

It was no accident that the prostitutes on Market Street and the Chinese of Hop Alley were located so close together. As segments of society so universally spurned, they found some degree of camaraderie and comfort

in each other's presence. Both underdogs, these outcasts found in each other friends. This friendship would prove to be very beneficial on Halloween night 1880.

On that night, a race riot took place that did extensive damage to the confines of Hop Alley as the anti-Chinese sentiment was given its ugly voice. The drunken mob descended on any hapless Chinese person they could catch, killing one poor elderly man, Mr. Sing Lee, who was simply in the wrong place at the wrong time and too feeble to get away. It is said that his ghost haunts Coors Field. More important than this urban legend (I would love to find it so but have yet to meet anyone who has actually seen the ghost of the murdered man) is the ghost of a neighborhood that was left behind. Denver is a large city that had a bustling and vibrant Chinese population, but today it is a city without a Chinatown, by virtue of racism. Though not restricted to Denver by any means (the federal government would, after all, pass the Chinese Exclusion Act a mere two years later), it is a sad thing for us here in Denver, for a wonderful part of our cultural tapestry was lost.

As it happens, there is another spirit that lingers with us from that night, a ghost much nobler in type and one we should have reason to see with pride. Whatever the girls on the Row might have been in the eyes of the rest of "good" society, on that night they were heroines. According to the newspaper the following morning, reporting on the riot, many more Chinese would have died at the devouring hands of the ruthless mob, but the Chinese had, in great numbers, fled into the bordellos that neighbored their businesses in Hop Alley. The newspaper shared this epitome of bravery in the face of stupidity: as the drunken bummers insisted the women send out the Chinese who were being harbored within, the women fought them back with broken champagne bottles and high heel shoes. Whatever you may think about these particular women, that night they saved many innocent lives, and Denver owes their memory a debt of thanks. What a great city!

As you are walking along Blake, be watchful for 17th Street. Turn right to get back to the intersection of 17th and Wazee. There you will find the Oxford Hotel, where our tour began and where we will shortly be ending it. As you wend your way toward this grand hotel, however, let's cheer you up with a little romance. After everything you have read, that should be just the thing, the icing on a grisly set of tales and the ghosts attached to them. If any of you happen to be single ladies, then what I am about to say applies to you especially.

Consider that the holiday for romance in the days of long ago was not Valentine's Day. No, the holiday when you did your best to find a spouse was actually Halloween. Yes, that's right, the time when the forces from the other side (like your dearly departed ancestors who are hoping to see you happily married and settled down) might lend a helping hand. Failing that, you might actually be able to reach other forces, perhaps less savory but no less willing to help you in your hunt, pathetic and horny or noble and loving.

Trips to palm readers, those possessing insight into jeweled dragons of the Amalfi Coast transformed into tarot cards and others who practiced the arts of the prestidigitator would help you find that all-important spouse, your ticket to love, financial security and children. Well, it was often more about financial security for the woman, since the Victorian era offered very few avenues of advancement for that sex. You could be an old maid (never a particularly desirable option), a wife or a worker. Remember that the choices of working position were quite limited, often poorly and unfairly paid, and that most men considered a woman working as a maid, cook, teacher or anything else to be one simple push from another, shall we say, less "upright" position. So finding a husband was a really big deal, ladies. It was the all-consuming quest of any young woman, and the magazines of the day knew that, catered to it, fueled it and profited off it. Imagine magazines today actually feeding you things to try to make you feel less than good about yourself. It defies belief!

Anyway, in researching the haunted practices of the past, we found a number of little nuggets of romantic wisdom oriented toward Halloween and ideal for helping you find your mate, ladies. Sorry, my good gentleman readers; nothing there for you. I guess they weren't worried about you having luck finding a marriage partner. It was all for the women seeking a man.

The first piece of advice involved a hemp seed, a thing very easy to get hold of in the old days when hemp was used to make paper, cloth and all manner of daily products for home and office. Actually, what am I saying? You might not be aware of this, especially if you are not from Colorado, but medical marijuana is legal in Colorado. So it's not as hard to get hold of a hemp seed in Colorado as it used to be, which will make your finding a husband, young and unmarried ladies, all the more easy.

So get a hemp seed and go out into the fields at night, finding the spot where the land owned by three different men comes together. As you plant the seed, speak the following invocation over it:

Street Walking with the Dead in LoDo

Hemp seed, I sow thee
Hemp seed, I sow thee
And him that is to be my love
Come after me and pull thee

If you then look over your shoulder into the night sky, you will see the face of your future husband.

Failing a hemp seed, ready access to numerous fields or the ability to determine without a GPS unit where the land of three different men comes together, you could try another method, much easier to accomplish with a simple trip to the supermarket and some instruments of vegetable torture. Get yourself a cabbage. It is better to pick the cabbage from the garden yourself, but in the modern day, we all have to make modifications, especially if dating websites have not proven successful. Perch the cabbage over your front door (if there is no way to perch it there, use a hammer and a large nail to spike that poor cruciferous thing into the wood over your door), and the next unmarried and unrelated man who walks beneath it is your future husband. Perhaps the cabbage will indicate your future husband, ladies, by falling on him. It could happen!

By now you should have reached the splendor that is the Oxford Hotel. Your tour has come full circle. I hope you have enjoyed it and not been too scared by anything shared along the way. As you make your way home, remember that the world around you holds much more than it seems. All I ask is that you open your eyes to the supernatural. If you find a ghost, then make friends, ask questions and do your best to keep the ghost occupied. In that way, there's a better chance that the ghost will never, ever come to visit me!

Bibliography

Arps, Louisa Ward. *Denver in Slices: A Historical Guide to the City*. Athens: Swallow Press/Ohio University Press, 1959.
Bettmann, Otto L. *The Good Old Days—They Were Terrible!* New York: Random House, 1974.
Denver Republican. Denver, CO, 1893.
Goodstein, Phil. *The Ghosts of Capitol Hill*. Denver, CO: New Social Publications, 1996.
Grinstead, Leigh A. *Molly Brown's Capitol Hill Neighborhood*. Denver, CO: Historic Denver, Inc., 1997.
Noel, Thomas Jacob. *Mile High City: An Illustrated History of Denver*. Denver, CO: Heritage Media Corporation, 1997.
Rocky Mountain News. Denver, CO, 1884, 1894.
Snow, Shawn M. *Denver's City Park and Whittier Neighborhoods*. Charleston, SC: Arcadia Publishing, 2009.
Tilden, John H. *Toxemia Explained*. Denver, CO: self-published, 1926.

About the Author

Though conceived in Florida and born in Virginia, Kevin was raised a little of everywhere, being a military brat. Upon reaching Colorado, he rather liked it, an impression that was corroborated by his visiting every state in the union and every single state capitol building. Finding Colorado the best place to be, he has settled down to pursue the work of growing Denver History Tours, with many joys (most of the tours) and many woes (the ghost parts). It has been a great life so far, and it is his fervent hope that when he goes, he won't end up joining the ghosts he has inadvertently associated with during his time as a guide.

Visit us at
www.historypress.net